FRANCIS FRITH'S

CALNE

LIVING MEMORIES

DEE LA VARDERA has lived and worked in Wiltshire since 1971.
A former Head of English in Calne, she has regularly written for the
Education Guardian, *The Lady*, *Wiltshire Life* and *Farmers Weekly*.
This is her fourth book for Francis Frith.

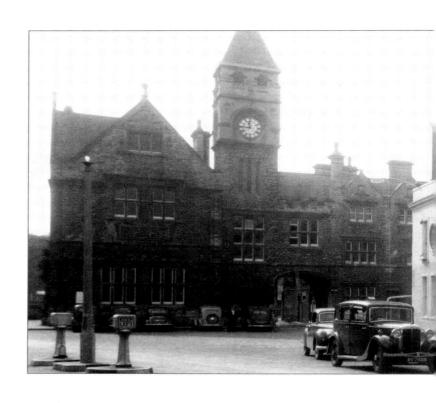

FRANCIS FRITH'S
PHOTOGRAPHIC MEMORIES

CALNE

LIVING MEMORIES

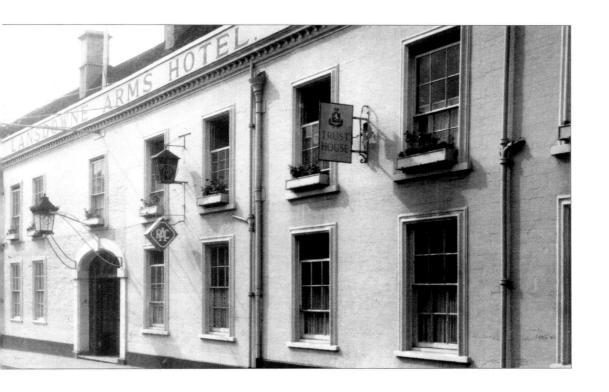

DEE LA VARDERA

First published in the United Kingdom in 2004 by
Frith Book Company Ltd

Limited Hardback Subscribers Edition Published in 2004
ISBN 1-85937-807-2

Paperback Edition 2004
ISBN 1-85937-808-0

British Library Cataloguing in Publication Data

Francis Frith's Calne - Living Memories
Dee La Vardera

Frith Book Company Ltd
Frith's Barn, Teffont,
Salisbury, Wiltshire SP3 5QP
Tel: +44 (0) 1722 716 376
Email: info@francisfrith.co.uk
www.francisfrith.co.uk

Printed and bound in Great Britain

Front Cover: **CALNE**, Wood Street c1950 C228052
Frontispiece: **CALNE**, The Town Hall and Lansdowne
 Arms Hotel c1955 c228041

*The colour-tinting is for illustrative purposes only, and is not intended to
be historically accurate*

The following images were supplied by Dee La Vardera:-
C228701 (p.13 and p.18-19), C228702 (p.25), C228703 (p.39),
C228704 (p.78), D706701 (p.80), D706702 (p.80), D706703 (p.81),
D228705 (p.82)

CONTENTS

Acknowledgements to Wiltshire County Library, Wiltshire Gazette and Herald, and Calne Town Council for advertisements and news items.

Particular thanks to Peter Treloar, Norman Beale, Don and Jean Lovelock, Tony Trotman, David and Margaret Morgan, Ted, David and Paul Buckeridge, Les and Maisie Edwards, Derek Merritt, Mike Thomas, Mary Morrish, Doug Cleverly, Jane Ridgwell, Brian Coombs, Roger Charlton of Beckhampton Stables, Denis Powney, Ros Cleal at The Alexander Keiller Museum (NT), Kate Fielden at Bowood Estate, The Fox Talbot Museum (NT), and Lacock Estate Office for their help and expertise. And to Alfred La Vardera for his support and advice.

Additional photographs by Dee La Vardera for Francis Frith.

FRANCIS FRITH
VICTORIAN PIONEER

FRANCIS FRITH, founder of the world-famous photographic archive, was a complex and multi-talented man. A devout Quaker and a highly successful Victorian businessman, he was philosophical by nature and pioneering in outlook.

By 1855 he had already established a wholesale grocery business in Liverpool, and sold it for the astonishing sum of £200,000, which is the equivalent today of over £15,000,000. Now a very rich man, he was able to indulge his passion for travel. As a child he had pored over travel books written by early explorers, and his fancy and imagination had been stirred by family holidays to the sublime mountain regions of Wales and Scotland. 'What lands of spirit-stirring and enriching scenes and places!' he had written. He was to return to these scenes of grandeur in later years to 'recapture the thousands of vivid and tender memories', but with a different purpose. Now in his thirties, and captivated by the new science of photography, Frith set out on a series of pioneering journeys up the Nile and to the

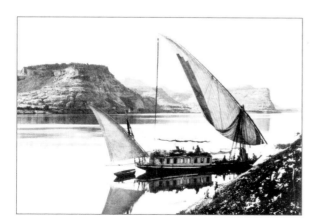

Near East that occupied him from 1856 until 1860.

INTRIGUE AND EXPLORATION

These far-flung journeys were packed with intrigue and adventure. In his life story, written when he was sixty-three, Frith tells of being held captive by bandits, and of fighting 'an awful midnight battle to the very point of surrender with a deadly pack of hungry, wild dogs'. Wearing flowing Arab costume, Frith arrived at Akaba by camel sixty years before Lawrence of Arabia, where he encountered 'desert princes and rival sheikhs, blazing with jewel-hilted swords'.

He was the first photographer to venture beyond the sixth cataract of the Nile. Africa was still the mysterious 'Dark Continent', and Stanley and Livingstone's historic meeting was a decade into the future. The conditions for picture taking confound belief. He laboured for hours in his wicker dark-room in the sweltering heat of the desert, while the volatile chemicals fizzed dangerously in their trays. Back in London he exhibited his photographs and was 'rapturously cheered' by members of the Royal Society. His reputation as a photographer was made overnight.

VENTURE OF A LIFE-TIME

Characteristically, Frith quickly spotted the opportunity to create a new business as a specialist publisher of photographs. He lived in an era of immense and sometimes violent change.

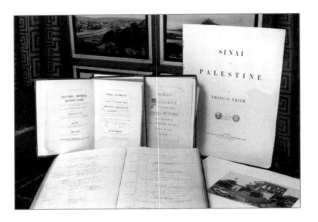

For the poor in the early part of Victoria's reign work was exhausting and the hours long, and people had precious little free time to enjoy themselves. Most had no transport other than a cart or gig at their disposal, and rarely travelled far beyond the boundaries of their own town or village. However, by the 1870s the railways had threaded their way across the country, and Bank Holidays and half-day Saturdays had been made obligatory by Act of Parliament. All of a sudden the working man and his family were able to enjoy days out and see a little more of the world.

With typical business acumen, Francis Frith foresaw that these new tourists would enjoy having souvenirs to commemorate their days out. In 1860 he married Mary Ann Rosling and set out on a new career: his aim was to photograph every city, town and village in Britain. For the next thirty years he travelled the country by train and by pony and trap, producing fine photographs of seaside resorts and beauty spots that were keenly bought by millions of Victorians. These prints were painstakingly pasted into family albums and pored over during the dark nights of winter, rekindling precious memories of summer excursions.

THE RISE OF FRITH & CO

Frith's studio was soon supplying retail shops all over the country. To meet the demand he gathered about him a small team of photographers, and published the work of independent artist-photographers of the calibre of Roger Fenton and Francis Bedford. In order to gain some understanding of the scale of Frith's business one only has to look at the catalogue issued by Frith & Co in 1886: it runs to some 670 pages, listing not only many thousands of views of the British Isles but also many photographs of most European countries, and China, Japan, the USA and Canada - note the sample page shown on page 9 from the hand-written Frith & Co ledgers recording the pictures. By 1890 Frith had created the greatest specialist photographic publishing company in the world, with over 2,000 sales outlets - more than the combined number that Boots and WH Smith have today! The picture on the next page shows the Frith & Co display board at Ingleton in the Yorkshire Dales (left of window). Beautifully constructed with a mahogany frame and gilt inserts, it could display up to a dozen local scenes.

POSTCARD BONANZA

The ever-popular holiday postcard we know today took many years to develop. In 1870 the Post Office issued the first plain cards, with a pre-printed stamp on one face. In 1894 they allowed other publishers' cards to be sent through the mail with an attached adhesive halfpenny stamp. Demand grew rapidly, and in 1895 a new size of postcard was permitted called the court card, but there was little room for illustration. In 1899, a year after Frith's death, a new card measuring 5.5 x 3.5 inches became the standard format, but it was not until 1902 that the divided back came into being, so that the address and message could be on one face and a full-size illustration on the other. Frith & Co were in the vanguard of postcard development: Frith's sons Eustace and Cyril continued their father's monumental task, expanding the number of views offered to the public and recording more and more places in Britain, as the

coasts and countryside were opened up to mass travel.

Francis Frith had died in 1898 at his villa in Cannes, his great project still growing. The archive he created continued in business for another seventy years. By 1970 it contained over a third of a million pictures showing 7,000 British towns and villages.

FRANCIS FRITH'S LEGACY

Frith's legacy to us today is of immense significance and value, for the magnificent archive of evocative photographs he created provides a unique record of change in the cities, towns and villages throughout Britain over a century and more. Frith and his fellow studio photographers revisited locations many times down the years to update their views, compiling for us an enthralling and colourful pageant of British life and character.

We are fortunate that Frith was dedicated to recording the minutiae of everyday life. For it is this sheer wealth of visual data, the painstaking chronicle of changes in dress, transport, street layouts, buildings, housing, engineering and landscape that captivates us so much today. His remarkable images offer us a powerful link with the past and with the lives of our ancestors.

THE VALUE OF THE ARCHIVE TODAY

Computers have now made it possible for Frith's many thousands of images to be accessed almost instantly. Frith's images are increasingly used as visual resources, by social historians, by researchers into genealogy and ancestry, by architects and town planners, and by teachers involved in local history projects.

In addition, the archive offers every one of us an opportunity to examine the places where we and our families have lived and worked down the years. Highly successful in Frith's own era, the archive is now, a century and more on, entering a new phase of popularity. Historians consider the Francis Frith Collection to be of prime national importance. It is the only archive of its kind remaining in private ownership. Francis Frith's archive is now housed in an historic timber barn in the beautiful village of Teffont in Wiltshire. Its founder would not recognize the archive office as it is today. In place of the many thousands of dusty boxes containing glass plate negatives and an all-pervading odour of photographic chemicals, there are now ranks of computer screens. He would be amazed to watch his images travelling round the world at unimaginable speeds through internet lines.

The archive's future is both bright and exciting. Francis Frith, with his unshakeable belief in making photographs available to the greatest number of people, would undoubtedly approve of what is being done today with his lifetime's work. His photographs depicting our shared past are now bringing pleasure and enlightenment to millions around the world a century and more after his death.

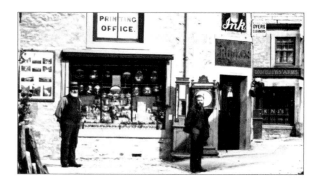

CALNE

FROM FLEECES TO FAGGOTS: AN INTRODUCTION

TWO ANIMALS best symbolise the fortunes of Calne over the past six hundred years: the sheep and the pig. Local artist, Richard Cowdy, has captured these animals in his bronze sculptures. One, at the entrance to Phelps Parade, shows a reclining sow with her mate; the other, on the forecourt of Sainsbury's superstore, captures a ewe and her lamb. The wool industry and then the production of bacon and ham have been at the centre of the town's economy and shaped its history and character up until the early 1980s. Calne is a place which has had to rebuild itself after the decline of its local industry, a town which has had to redefine itself and find a new identity.

Situated on the river Marden, which flows into the Avon, the eastern part of Calne lies below the chalkland of the western edge of the Marlborough Downs in north Wiltshire. The western part, flat lowland, lies on a mixture of coral rag and clay. It is a fertile region with a long history of arable, sheep and dairy farming. Six miles to the west is Chippenham which provides valuable rail links and access to the motorway, and eight miles to the south is Devizes. The

market town of Marlborough, famous for its public school, is 15 minutes by car, and the Roman city of Bath about 40 minutes. This north-west corner of the county is rich in places of historical interest such as Silbury Hill, the Kennet long barrow and Avebury stone circle, just a few miles up the road. In the opposite direction is the village of Lacock with its famous Lacock Abbey and the Fox Talbot Photographic Museum. Closer is Bowood House, the family home of the Marquis and Marchioness of Lansdowne, with its magnificent Capability Brown parkland.

Calne lies on the old coaching route from Bristol to London, which runs through some of the most beautiful countryside in Wiltshire. The Georgian traveller would have been spoilt for places to visit en route to take the waters in Bath. He might have stopped to visit friends in Marlborough, or to view the white horses and stone circles in the area, and he probably changed his horses at Beckhampton or at the Lansdowne Arms. In 1811 it took 11 hours 50 minutes to go from London to Calne by mail coach, an average of 7.6 mph. It had improved

to 9 hours 26 minutes by 1836, a speed of 9.54 mph. There was obviously plenty of time to soak in the views and enjoy the gossip on a long journey, but undoubtedly refreshment and rest stops were eagerly anticipated.

Calne was a centre of the woollen trade from early medieval times; the town's prosperity is reflected in fine Georgian buildings such as those on the Green, which were built at the height of its prosperity. A large part of the town centre, mainly concentrated on the Strand, the church and the Green, is now a conservation area. In 1801, John Britton records that Calne 'contains nearly three thousand inhabitants, most of whom are employed in the manufacture of broad-cloth, serges, and various other articles of the clothing business'. As the cloth industry declined in the town and the county in the early 19th century, another industry was gradually taking root. The Harris family bacon business became the most important industry in the town for nearly 150 years. Calne was blessed with good canal and rail links which helped the business to expand, and Wiltshire Cure bacon and hams became famous throughout the country. Calne became synonymous with quality pork products, and generations of locals worked all their lives in the factory and expected 'jobs for life'.

Everything seemed to centre on this industry, and it was at the very heart of the lives of thousands of people. Generations were employed in work related to the factory, and locals spent their wages in Calne shops and businesses.

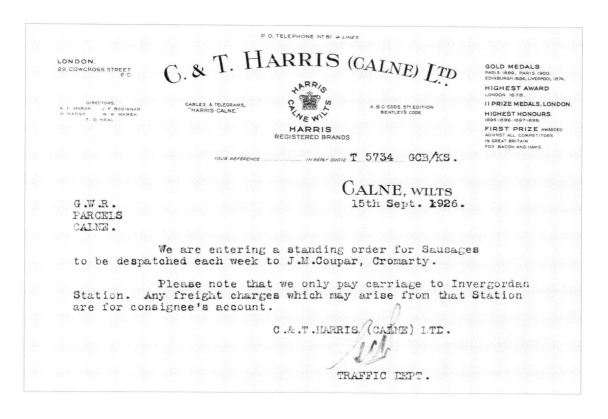

Thanks to the benevolence of the early Harris family, residents benefited from their gifts to the town of public buildings, houses and recreation areas, as well as their support of the parish church. The factory closed in 1982 after struggling through the recession and trying to beat off overseas competition and changes in tastes in food. This caused much emotional and psychological heartache to the town's people as well as financial hardship. When the buildings were finally demolished, the heart of the town seemed to have been ripped out. However, with the opening up of this central site, the potential for redevelopment was obvious. A charitable organisation called The Calne Project was

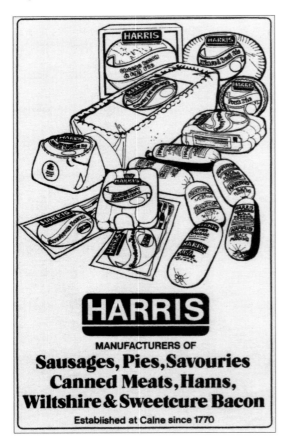

HARRIS

MANUFACTURERS OF
**Sausages, Pies, Savouries
Canned Meats, Hams,
Wiltshire & Sweetcure Bacon**

Established at Calne since 1770

formed in 1985 by local councils and supported by English Heritage; it produced a blueprint for redevelopment which has now been largely carried out by North Wiltshire District Council. It has taken nearly two decades for the regeneration of the town centre and a new identity for Calne and its people to emerge. The River Marden had been hidden within the Harris's building for many years. Today, thanks to some extraordinary feats of engineering, it has been opened up and diverted to create an attractive focus with the new library and riverside complex.

In an early 1970s town guide, Peter Treloar writes about the town's 'remarkable self-sufficiency'. Before the First World War, the town had its own water and gas companies and electricity supply, its own cattle market and railway line, and its own craftsmen and iron foundry, all able to supply the needs of the huge Harris's enterprise. It had its own Borough Council established under the Municipal Corporations Act of 1835, and its constitution of twelve councillors and four aldermen remained until local government re-organisation in 1974. The Town Council now comprises fifteen members, four of whom also serve on the District Council. Their offices relocated to Bank House in 1999.

The 1901 census returns give the population of Calne as 3,456. By 1931 it had grown to 4,360 and by 1961 to 6,550. The most growth can be seen in the last twenty years: the population had risen to 13,000 by 2002. According to Vol XV11 of *The Victoria History of the County of Wiltshire*, in 1899 there were about 100 retailers who had premises in town, including about 30 in Church Street. In 2001 there were about 25

retail shops on the left bank of the river Marden, including those in Church Street along with a small supermarket, and 50 retail shops on the right bank, including those in the High Street and Phelps Parade, which opened in 1973, and a large supermarket opened in 1998. The Sports Centre opened in 1976.

Calne is home now to a wide range of businesses, such as manufacturers of PVC-U extrusions and of electronic components for domestic power distribution and for railway engines world-wide. There are also printers, furniture and kitchen makers, agricultural merchants, and manufacturers of ice cream. New jobs and new housing developments have attracted people to the town, and so has the thriving cultural life. The Calne Artists' Group, the annual music and arts festival, the regular concerts and film shows and the variety of clubs and societies have contributed to the cultural dynamism of the town.

As with any place which loses its main source of employment, and consequently its sense of identity and purpose, Calne has had to re-invent itself.

The town now moves into the 21st century with a completely different reputation and lifestyle, yet retaining and preserving what was good of the past.

WILTSHIRE & SONS

Photo by courtesy of Wiltshire Newspapers Ltd.

No Official Guide needed

EVERYONE KNOWS

WILTSHIRES MODERN FOOD STORE

Make your shopping a pleasure by purchasing from our complete range of food commodities — ALL your needs for the family each week

CALNE, THE STRAND AND THE NEW LIBRARY 2003 C228701

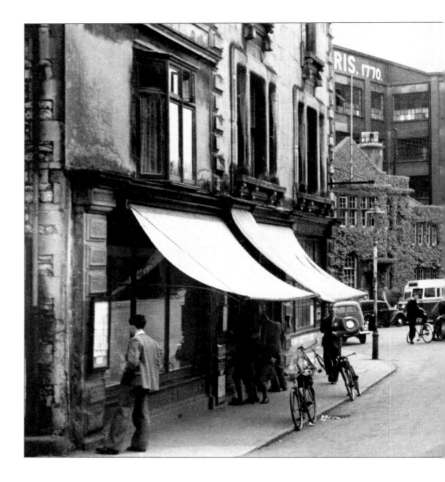

THE STRAND c1955 C228013

The Royal Arms and 'By Appointment to Her Majesty Queen Elizabeth II' can be seen proudly displayed on the front of the building. Brian Coombs, who drove delivery lorries in the 1960s and 70s, remembers making several runs to Windsor Castle to deliver sausages and bacon.

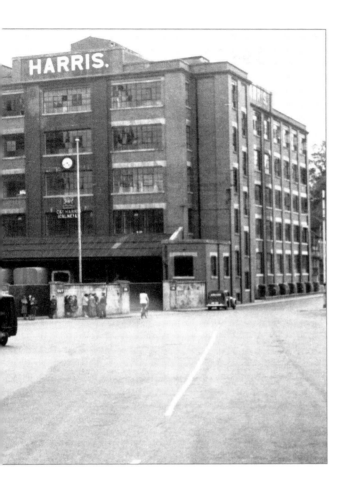

THIS LITTLE PIGGY WENT TO … :

THE HISTORY OF C & T HARRIS (CALNE) LTD

FROM a small pork butcher's shop in Butchers Row (now Church Street) run by Sarah Harris and her son John in 1770, to a factory supplying food products around the world, the name of Harris's has been synonymous with the town for more than a century. Its slogan 'We're just as much part of Calne as Calne is a part of us' illustrated the importance of the business to the economy and reputation of the town. Wiltshire had long had a reputation for producing quality bacon cured on the farms, but it was not until the 1840s that Calne became the focus for large-scale production.

John Harris died in 1791, and his son John opened his own butcher's shop in 1805 at the corner of the High Street. Various other sons helped in different businesses in town and introduced and developed new ideas - Henry added bacon curing to his business, for instance. When the supply of Irish pigs was disrupted by the Irish potato famine of 1847, George, the youngest son of John Harris II, went to America to see if bacon could be cured and exported home. He learned how to use ice for cooling purposes and introduced the method in Calne on his return. The first ice house was built in 1856 and the process was

HARRIS'S INTERESTING FACT

THE NUMBER OF PERSONNEL GREW FROM 651 IN 1917 TO 2,116 IN 1957.

15

patented in 1864 by Thomas.

The amalgamation of Charles and Thomas Harris's businesses in 1888 created the beginnings of the modern company, C & T Harris Ltd. The factory rapidly expanded from 1900 onward. By 1920 the Harris family had ceased to control the business, although George Henry continued to be associated with it. In 1925 they merged with Marsh & Baxter, famous for their York hams. In 1929 a Royal Warrant was granted as Bacon Curers to George V. In 1930 the by-products factory was built to produce fertiliser, animal feed, soap, bristles for brushes and curled hair for upholstery - nothing was wasted, it seems. The demand for sausages, drycure bacons and new

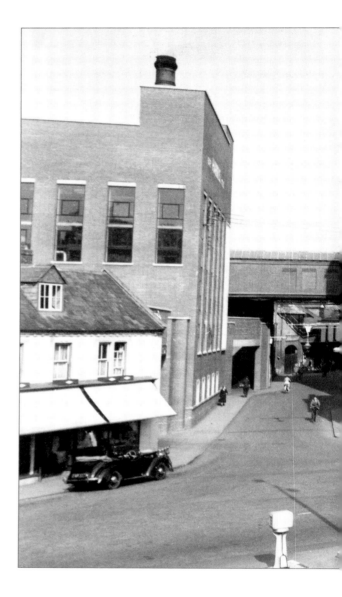

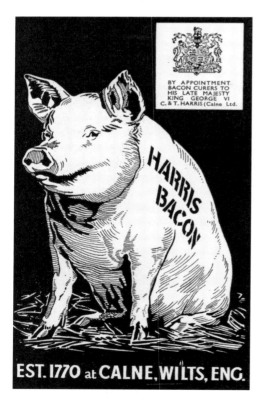

food products prompted further building expansion.

In 1962 C & T Harris was taken over by the Fatstock Marketing Company (FMC) group, which was the largest meat marketing organisation in Europe. Unfortunately, the recession of the 1980s affected business and the factory closed down in 1982.

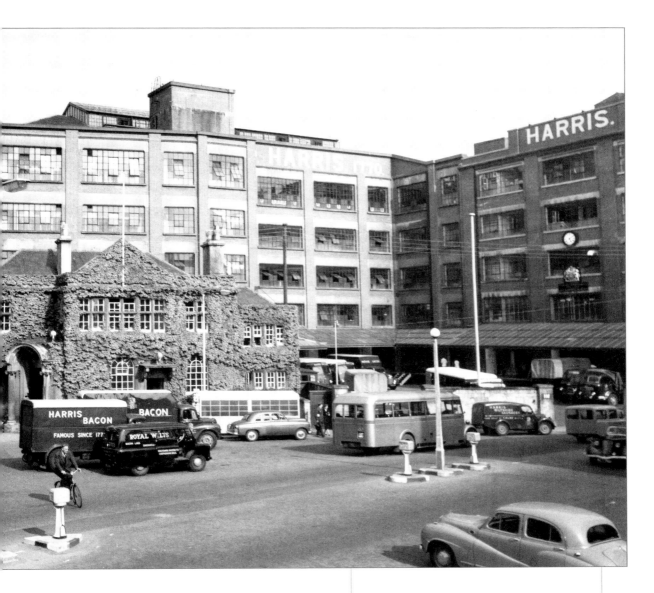

HARRIS'S FACTORY c1960 C228058

Cattybrook No 2 Factory was brick built in 1932, 'steel framed with a Georgian-wired glass roof on a single span' (John Bromham's *Brief History*). To the left is the 1955 boiler house, with the top of the 100ft chimney built in 1918 just visible.

MEMORIES OF WORKING LIFE

Derek Merritt started work in the slaughterhouse at 14 in 1941 at 15s for a six-day week. He worked for Harris's for over forty years, and said: 'you couldn't work with a better lot of men'. On average they killed 1000 pigs a day, but one

day they clocked up '1200 before dinner'. Harris's were very good employers. He remembers as a boy when the whole warehouse floor and loading bay were cleared for the Christmas carnival, and there were 'girls in fancy dress, a makeshift band and a present for every child'.

David Morgan was an engineer from 1951 to 1982. His 1964 contract of employment established between Harris's and the Amalgamated Engineering Union set out his weekly working hours as 42, exclusive of one hour per day for lunch, with pay of £14 5s 0d. He met his wife, Margaret Gregory, who worked in the accounts department in Bank House. David said, 'I used to work in the old boiler house opposite and used to wave across at the young ladies in the offices. Margaret also used to come up and do the teas for the Harris's cricket matches when I played.'

Doug Cleverly, the only Calne man to have been Mayor of Chippenham twice, also worked as an engineer in the 1940s and 50s. He was a fitter and turner for a time in the tool shop. He learned a wide variety of skills, which enabled him to 'do a bit of everything', including making conveyor belts, metal pipes for the boiler house, and pie cans; he even maintained the lifts. He remembers having to put new paddles on the shaft of the mixers at the by-products factory. 'You had to get right inside these huge cylinders. You always took the fuse with you in case anyone started the machine up, which did happen once. Fortunately the man managed to climb out pretty sharpish.'

Les Edwards, now 76 years old, started in the factory at the age of 14. Apart from a spell in the seasoning department, he worked in the boning

THE STRAND AND THE NEW LIBRARY 2003 C228701

The Millennium Library was opened by the Queen in December 2001. It is the centrepiece of the new riverside development on the former Harris's site; it was designed by Aaron Evans Associates of Bath in a post-modern style, faced in Bath stone. The Head Sculpture, designed by Herefordshire artist, Rick Kirby, has been a talking point ever since its installation.

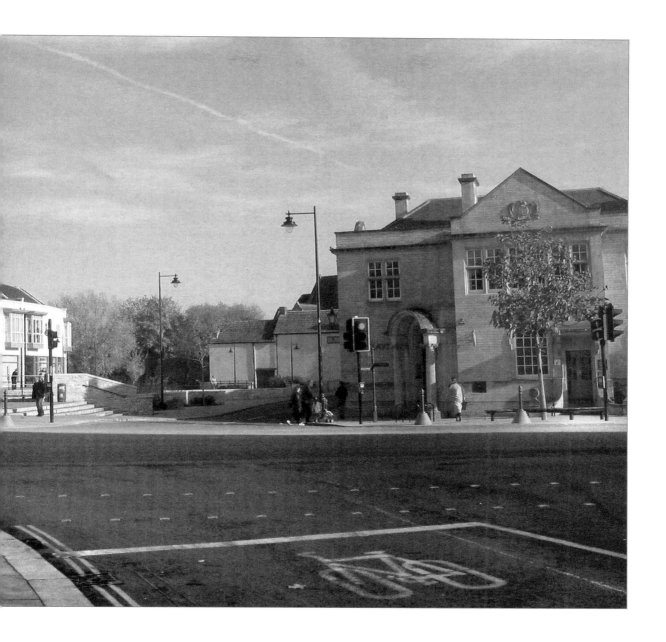

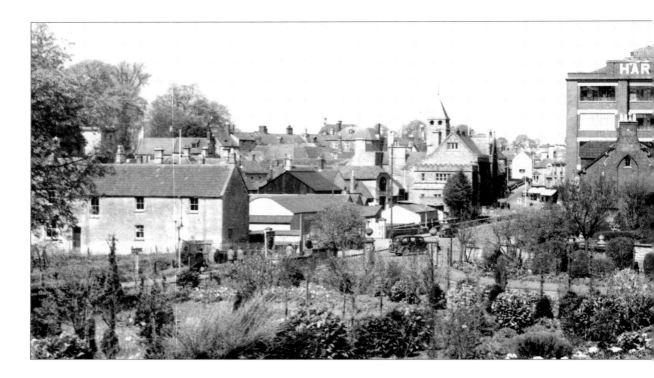

department until the factory closed in 1982. He remembers as a boy being sent by the foreman to drive pigs up from the station when they arrived by train before lorries were used. He learned to bone and joint pork, beef, veal and chickens in preparation for the different products. 'There were quite a few women in the department, 20 or 30, plus 40 men.' His wife Maisie, née Trundle, worked as a messenger, taking invoices around town on a bicycle. She worked for a while in the pie room. 'I enjoyed putting the jelly in the holes,' she remembers; but she did not like the cold, and moved to the printing department, where she stitched the handmade boxes. They came already creased and she had to put three stitches in each corner using a foot pedal-driven machine.

Mary Morrish, née Williams, worked in the pie department in the early 1970s. She remembers the jellying department where they changed into wooden clogs with metal soles to work. 'They made the jelly upstairs in huge containers and it was then piped downstairs. We had a sort of hose pipe with a gun attachment to inject the jelly into the holes of the cooked and cooled-down pies.'

Everyone had a part to play, however small, in the local economy of Harris's. Edward Holman, contributing to Gladys Daniels' book *Memories of Derry Hill Village* (1990), wrote about the pig which most cottagers kept. 'The manure was useful and there was an instant market for the pigs at C & T Harris in Calne'. John Bromham records in his *Memoirs of a Small Town Man* how as a boy he played football with blown-up cured pig's bladders from Harris's before they were filled with

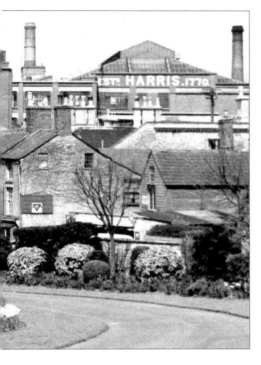

lard and sold. 'Their life was pretty short, but they made good footballs.'

THE VIEW FROM THE WOODLANDS c1955 C228039

This view shows the dominance of the Harris's factory on the Calne skyline. The Town Hall is in the centre. On the left is the former canal building, Marden House, at the termination of the Calne branch of the Wiltshire and Berkshire Canal, probably originally occupied by the wharfinger. It is now a community centre.

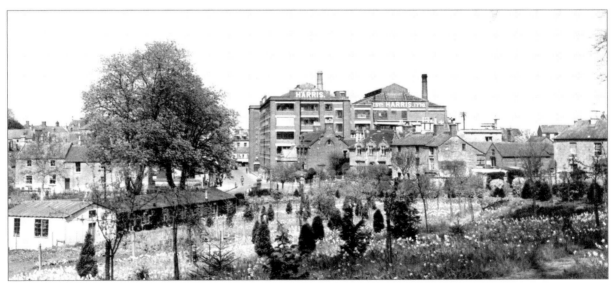

THE VIEW FROM THE WOODLANDS c1955 C228036

This view from the grounds of The Woodlands shows a long, low wooden hut (left), which served as the Station Road Surgery of Drs Grant and Rivett in the 1960s. In spite of its humble appearance and size, it became a forward-looking practice, employing a receptionist and nurse instead of relying on 'long-suffering wives', according to Dr Beale in his book *Is That the Doctor*?

WOODLANDS CLUB HOUSE c1955 ▶
C228028

The drive of the former Harris family home, which was built c1870, gave access to the Harris Welfare Association Woodlands Club House, which was established in the former woollen mill to the left. An example of the activities there was reported in *The Wiltshire Gazette* of 3 August 1950: 'For the less energetic a whist drive was held on Friday when 14 tables were occupied … Mr Drew was instructor at an old-time practice dance on Tuesday, when the not-so-skilled were put through their paces in the Lancers and Dutch Foursome. Music was by radiogram.'

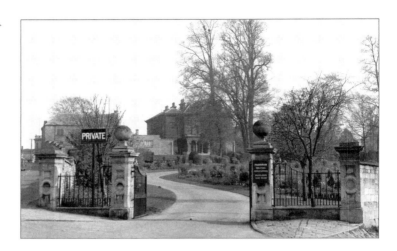

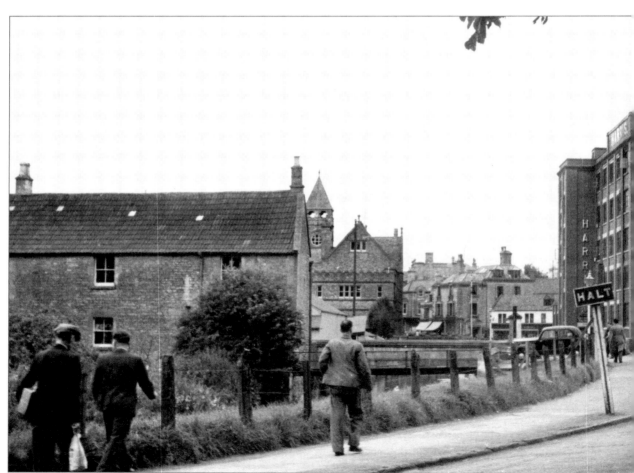

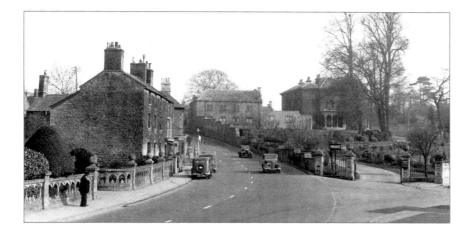

THE WOODLANDS AND NEW ROAD c1955
C228027

The house was designed in 'eclectic Renaissance style', but it was demolished in 1983. Houses have been built in much of the ground of the Woodlands. The roundabout here in New Road now goes right into Station Road, which leads to a housing development and the fire station. Kerry Crescent (left), with its ornate entrance to Ivy Walk, remains unchanged.

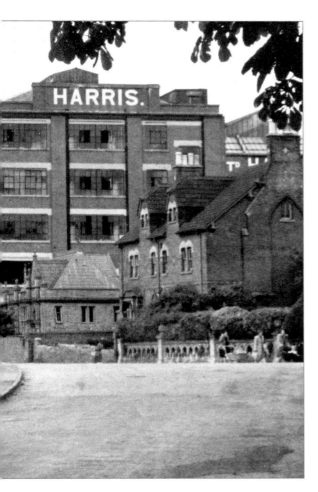

THE VIEW FROM STATION ROAD c1950 C228002

A train has just arrived at the station, and Harris's workers are seen coming up Station Road to the factory. Notice the road sign (centre) for motorists exiting onto the main road: it is made from a railway halt sign set on a section of broad gauge rail. On the left is Marden House, now a community centre, formerly a Harris's store for invoices and papers.

HARRIS'S
INTERESTING FACT

Electricity was generated privately by C & T Harris Ltd from 1926, and the company supplied power to the town and Calne Without Parish until 1948.

THE RIVER MARDEN AND NEW ROAD c1955 C228026

Harris's owned the wharf, which was used for their vehicles and storage. Gas lights are still evident on the centre wall. Storah's outfitters and drapers is in the centre on the corner of Church Street. The St Dunstan's factory wing (right) was built in 1919. The basement was used for pie cooling and packing; the ground floor for pie making; the first floor for offices; the second for sausages; the third for canning; and the fourth for the kitchen and cooking (John Bromham's *Brief History*).

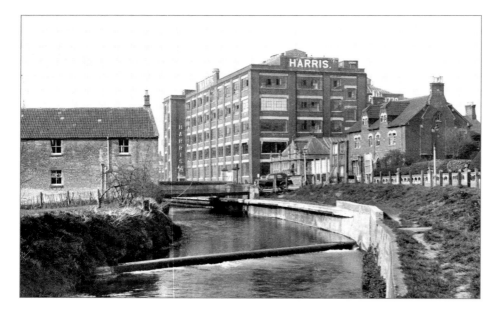

▲

THE RIVER MARDEN AND THE HARRIS BACON FACTORY c1955 C228029

The huge 1919 wing of Harris's factory contrasts with the one-storey Carnegie Library. The library was built in 1904-05 with £1200 donated by Andrew Carnegie, the American philanthropist. Thomas Harris also donated £400, as well as the land. The librarian Sue Boddington's book *A Source of Pride* gives a delightful insight into its history. In 1940 'the Reading Rooms were taken over by the Food Office and became a centre for the issue and stamping of ration books'. The place was gas-lit and heated by steam from Harris's up until 1951. It is currently undergoing renovation with the view to its opening as a Heritage Centre.

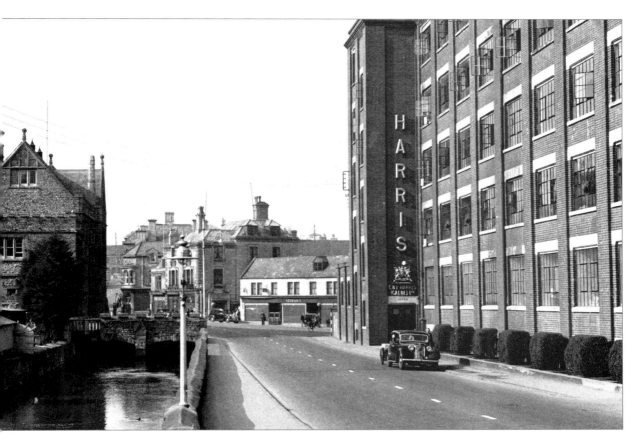

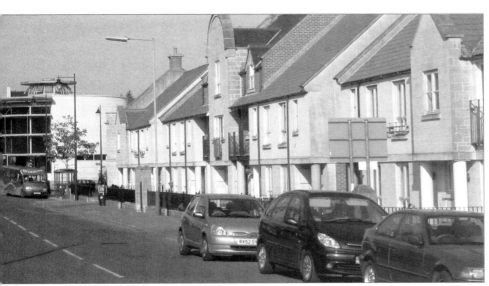

◀ **THE RIVER MARDEN AND NEW ROAD 2003** C228702

A new development of houses called Carnegie Mews was built on the Harris's site, right. It has attractive iron railings with unusual leaf motif decorations, designed by local artist Peter Collyer. The new library dominates the view towards The Strand.

HARRIS'S INTERESTING FACT

At its height of production, Harris's factory could process 5,000 pigs a week, out of which 150 tons of sausages, 50 tons of cooked meats, 70 tons of canned goods and 100 tons of meat pies were produced.

THE STRAND c1960 C228060

Stanley's the confectioners (right), with the Strand Café above, housed in the former post office and telephone exchange, was popular with locals. Most of the buildings were compulsorily purchased for demolition in 1968 for the widening of the A4.

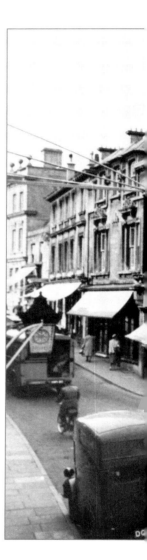

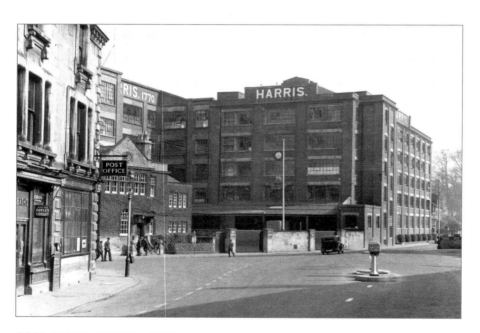

POST OFFICE CORNER c1955 C228025

This view shows (left), at No 7 The Strand, Heath's printers, bookbinders and stationers, with its own lending library. Mike Thomas remembers it in the 1950s also as 'an Aladdin's cave of toy cars and train sets'. Next door was the telephone exchange, and the post office was on the corner.

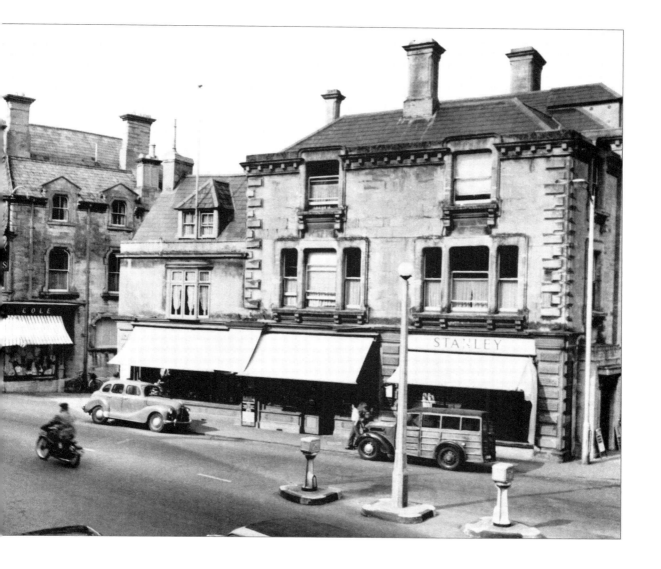

HARRIS'S INTERESTING FACT

In 1960 a new sausage called the Western Sausage (its main ingredient was neck trimmings from chicken factories) was heavily promoted by salesmen dressed as cowboys shooting pistols, and cowgirls giving away samples. When one of the directors was asked how it was going, he replied, 'I am calling them Boomerang Sausages - they are all coming back'. The sausage was withdrawn soon after.

**THE LANSDOWNE ARMS
HOTEL c1955** C228034

This Grade II* listed building is a former coaching inn with its own stabling and brew house at the rear. It is an amalgamation of up to five domestic properties, which can still be seen from the rear courtyard. It has an impressive front with a range of fourteen sash windows and an unbroken parapet. In 1960 a single room with breakfast cost £1 7s 6d per night in the high season, with 3-course luncheon at 8s 0d, afternoon tea 3s 0d and 3-course dinner 9s 0d. Under its current management, the privately owned hotel has expanded its services to offers facilities for conferences and weddings.

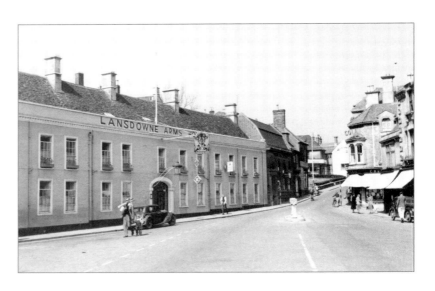

**THE TOWN HALL AND THE
LANSDOWNE ARMS
HOTEL c1955** C228041

The central arch was once the carriage entrance to the rear yard. A large ornamented wrought iron carriage lamp graces the entrance, with a large barometer in a moulded surround on the left-hand side. There is a fire insurer's mark dated 1696 on the left-hand wall.

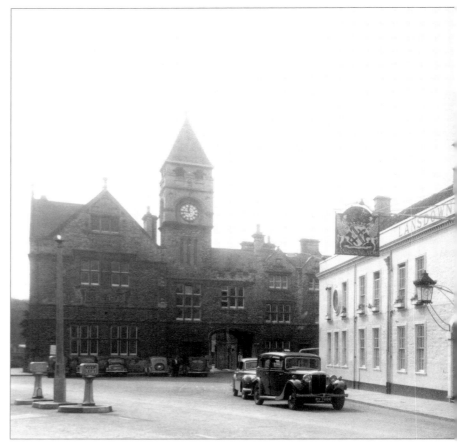

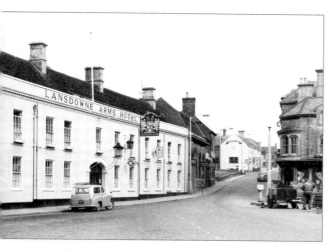

THE LANSDOWNE ARMS HOTEL c1960 C228055

CATTLE, COACHES & COCKTAILS:

THE STRAND, THE LANSDOWNE ARMS HOTEL AND THE TOWN HALL

THE STRAND has always been at the heart of the town, where people met to trade as well as socialise. The market was central to the town's economy for centuries. The large area was also the scene of many public meetings, parades and civic ceremonies. The road sweeps past the Lansdowne Arms Hotel and, before the A4 road widening, it curved gently up the High Street past imposing shops and banks. The elegance of the Georgian coaching inn was always slightly at odds with the functional Victorian industrial red brick factory of Harris's opposite.

Although it is said that there was an inn here as early as 1582, records show the Catherine wheel inn first mentioned in 1660; it was known as the Wheel until the 1820s, when it became the Lansdowne Arms. It had its own brew house, described in 1924 sales particulars as comprising: 'Cooling Room Floor. Malt Store. Tank Floor. Sugar Room. Mash Tun Floor. Hop Store. Refrigerator Room. Cask and Bottle Washing Floor. Engine Room. Hop Back Room. Furnace Place and Fermenting Room'. The hotel changed its name to The Lansdowne Strand in 1999 so as not to be confused, perhaps, with the Derry Hill public house.

THE STRAND c1955
C228012

At Nos 1 & 3 High Street was J H Cole & Sons, a drapers (left). It was a high-class shop, and offered many services. David Morgan, an engineer at Harris's for over thirty years, used to be a delivery boy, and remembers polishing the big brass window sill every Saturday morning for 10s a week. The shop closed in 1968 when it was demolished as part of the road widening scheme.

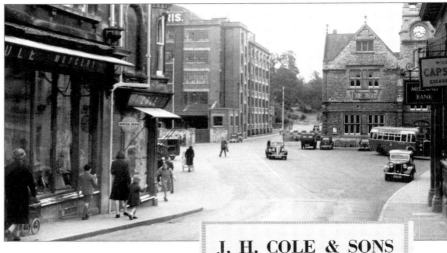

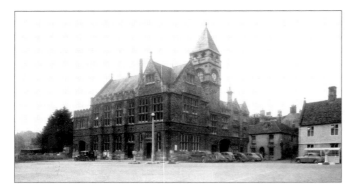

THE TOWN HALL c1955 C228040

The Town Hall was built on the site of the town watermill. It was designed by the Bath architect Bryan Oliver; it cost £9,375 4s 3d, and was opened in 1886. Described by Pevsner as 'Tudor with Gothic touches', it is still the centre of civic life.

J H COLE & SONS GENERAL DRAPERS 1950
from Town Guide (J Burrow)

J. H. COLE & SONS
— GENERAL DRAPERS —
Ladies' & Children's Outfitters

Cleaning & Dyeing by Achille Serre Ltd.
HOUSEHOLD LINEN SPECIALISTS
Earlywarm Witney Blankets
High Street at the Bus Centre **Calne**
Phone 2148

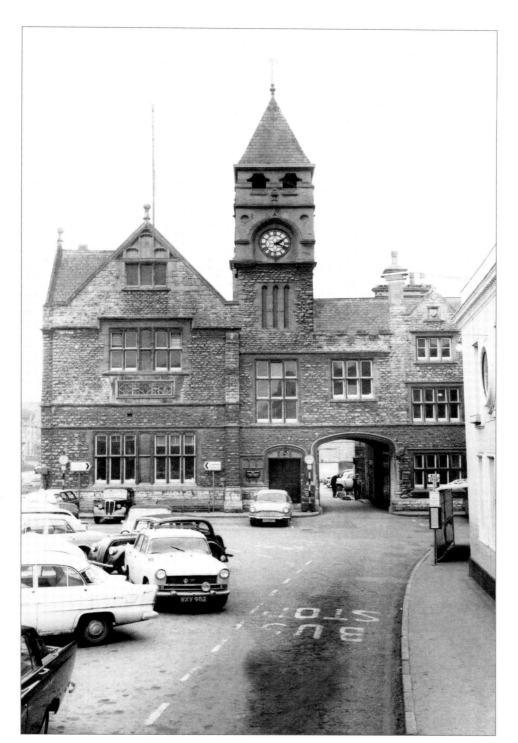

**THE TOWN HALL
c1965** C228108

The Town Hall is described as built with 'squared, coursed limestone rubble with slate roof' (*Department of Heritage List*). It has an irregular plan, with the council chamber on the left, the corn exchange behind and the town hall above, with a central clock tower and a carriage archway leading to the old fire station at the rear. The right-hand side has double-depth offices along Patford Street, which once housed the police station.

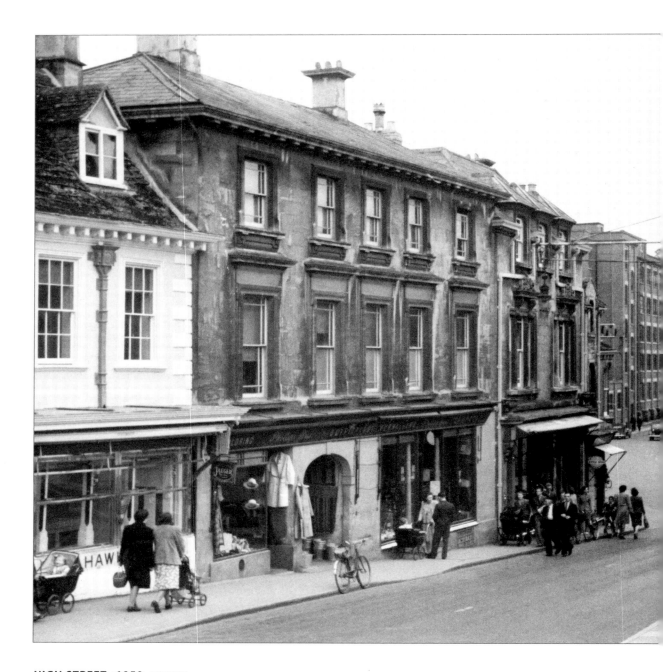

HIGH STREET c1950 C228007

On the left is Hawkins the butchers, with an interesting mix of periods: the building is late 17th-century with early 18th-century re-front and extension. The early 19th-century shop front has 'an ashlar stall riser beneath C20 plate-glass windows which curve to a left-hand doorway' and a 'timber modillion (ornamental bracket) cornice gutter' (*Department of National Heritage List*). Next to the arch is Tim Henly, gents' outfitters, and Phillips Bros, house furnishers at Nos 5 & 7.

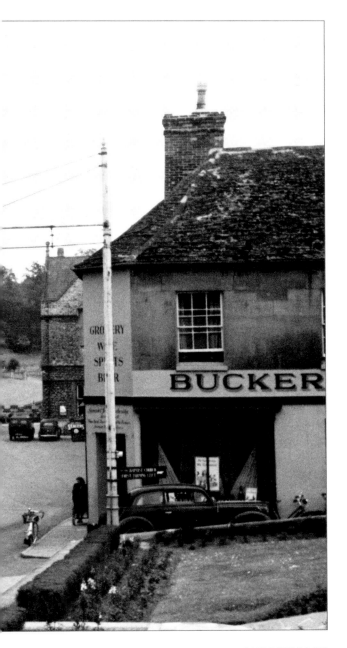

**PHILLIPS BROS
ADVERTISEMENT1939**

BEER, BOOTS AND BUNS:

HIGH STREET
AND MARKET HILL

IT WAS FROM the 1920s onwards that the High Street became more commercially important than Church Street. As more houses were built on the northern side of town, so residents needed shops closer to their homes. With the building of the Co-operative store in 1936 and the post office in 1953, this part of town became even busier, and could boast a wide variety of clothes and shoe shops as well as grocers, bakers, butchers and ironmongers.

BUCKERIDGES

Albert Wilkinson Buckeridge opened his grocer's and wine and spirit merchant's business in 1876 in the premises on the corner of Market Hill near the old town hall. His son, Launcelot John, took over just after the First World War and his four sons, John, Ted, Paul and David, went into partnership following the Second World War and continued with the business until 1988, when they retired and sold up.

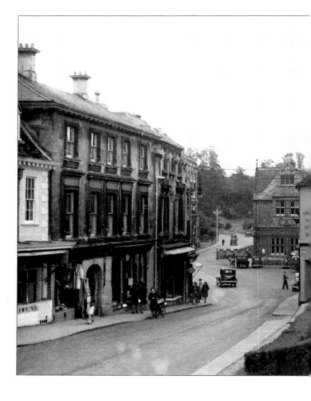

Established 1876

PERSONAL SERVICE FROM . . .

L. J. Buckeridge & Sons

WHOLESALE & RETAIL WINE AND SPIRIT MERCHANTS

Cheese and Continental Foods

Cigarettes, Tobacco and Smokers' Accessories

Glasses for Sale and Loan

6 HIGH STREET, CALNE, WILTS. Tel. 812381
SN11 0BJ

The family-run shop was an important part of the town's history for nearly 110 years, as well as a landmark premises. The steps up Market Hill are now called Buckeridges Steps. They had their own bottling plant and warehouse at the back and in Castle Street. All beers and wines came in large containers and would be put into small bottles and labelled. They were one of the few people licensed to bottle Guinness from Ireland under their own name. For many years they supplied all the local pubs and clubs with drinks, and were famous for their cheeses. They employed about twenty people in various jobs including bottling, delivering, preparing goods such as sugar and rice for sale, and packing customers' orders.

As the supermarkets were beginning to appear in the 1960s, they decided to specialise in the wine and beer side of the business but also to retain the specialist cheese side. Even though sales of wine were minimal in the early days, as people began to travel abroad more so tastes began to change. Ted Buckeridge, born in 1917, said, 'Everyone drank red wine in my day, wine from Tarragona in Spain, like a light port. We also sold South African wine bottled from the barrel'. In 1975 they advertised themselves as 'Wholesale & Retail Wine and Spirit Merchants', with the added glamour of: 'Cheese and Continental Foods, Cigarettes, Tobacco and Smokers' Accessories'.

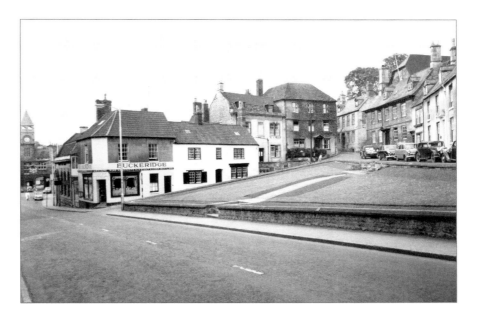

HIGH STREET AND MARKET HILL c1960 C228070

West Hill House, right, at the corner of Market Hill and Quarr Barton, is Grade II* listed; it was the home and surgery of Dr James for 42 years. Apart from the narrow Grip House, next door, the other buildings to its right were demolished for the A4 developments.

HIGH STREET c1950 C228011

The Buckeridge family lived next door to the off-licence and grocer's shop, but they moved when the business expanded after the Second World War. In 1950 they advertised themselves as 'Grocers & Wine Merchants' with the added title 'The Old Wine Shop', which is 'pleasantly situated by the Central Garden and close to the bus stop'.

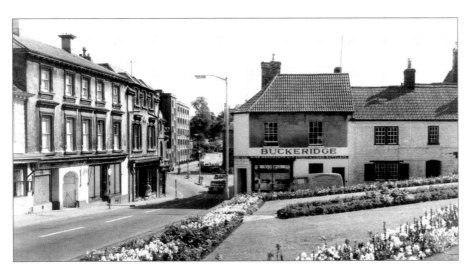

◄ CENTRAL GARDENS c1960 C228082

This was the site of the Old Town Hall. Thomas Harris paid for the enclosure and planting of the Central Gardens in 1896. They were demolished in 1968 to make way for the A4 road widening developments.

▼ MARKET HILL c1950 C228008

Market Hill House, Grade II* listed (centre), has had a variety of uses over the years: a doctor's house, a dormitory for St Mary's School and bank premises. In 1971 Spackman, Dale & Hood, solicitors, moved in from Patford Street, later becoming Bevirs. Inside is a 17th-century stone chimney piece bearing the arms of Walter Norborne, MP for the Borough in 1640, which was rescued from Castle House in 1974.

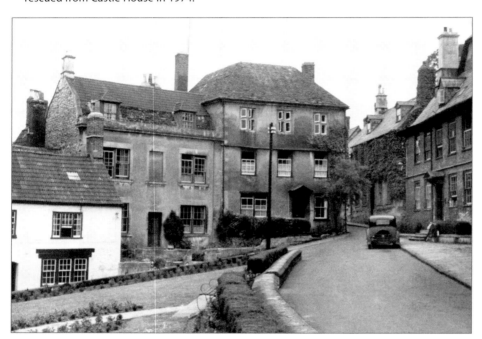

▶ HIGH STREET c1955
C228024

Herbert Bridges, the jewellers, at No 12 (the second building from the right) was a house and then a police station before becoming a shop. It is mid 18th-century with a coursed limestone rubble exterior. Next door is Jeary's the chemists, and then comes E G Fry & Son, the bakers, of Bremhill. Tony Trotman, who lived above his father's hardware shop at Nos 15-17, then trading as E W Brown & Co Ltd, remembers buying 'wonderful lardy cakes and cream doughnuts' from Mr Gingell, who ran the bakers.

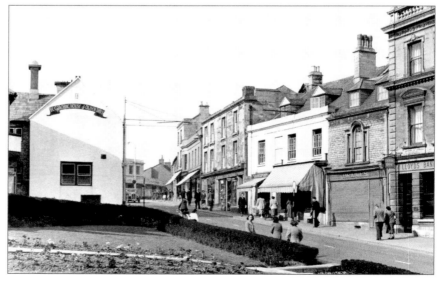

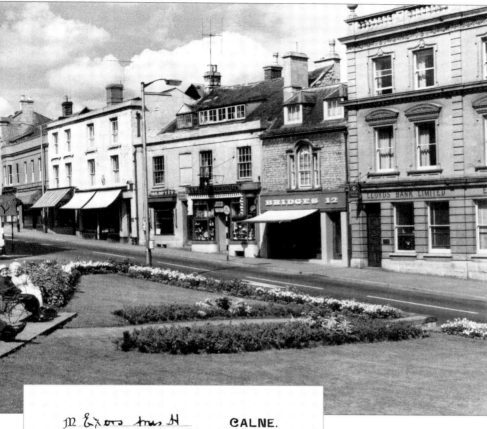

◄ **CENTRAL GARDENS c1960** C228081

The Lloyds Bank building (right), originally a pair of attached houses, was built about 1870 before the decorative façade was added in two stages. To the left is Henly's Store, established in 1810. Don Lovelock remembers going in to buy loose biscuits weighed out from the tin and the assistant breaking a piece off to make it up to a pound. They also had an overhead cable system for the cash to be sent to a central point. The shop was demolished along with the gardens as part of the road widening scheme.

INVOICE FOR HENLY STORES

▶ HIGH STREET c1955
C228009

The Kings Arms public house on the right, with the central open Tuscan portico with steps, dates from the 18th century, with mid 19th-century rear extensions. Notice the wonderful old street lamp stretching across to the centre of the road – it also appears in C228024 (page 36). R Mundy & Son's shoe shop is on the left at No 19.

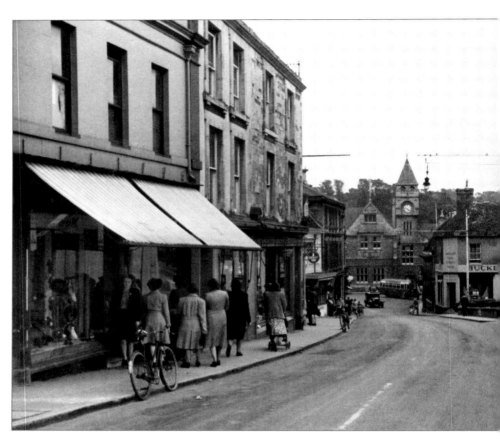

◀ HIGH STREET AND THE POST OFFICE c1960 C228069

The new post office was built on the corner of Curzon Street and High Street and opened in 1953. The ERII monogram is still above the door. This part of the High Street is now pedestrianised.

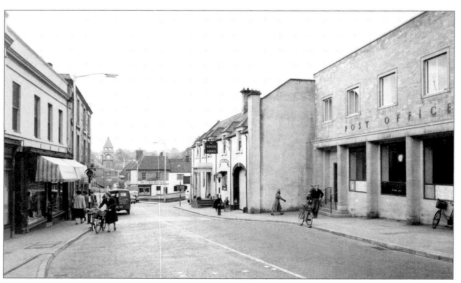

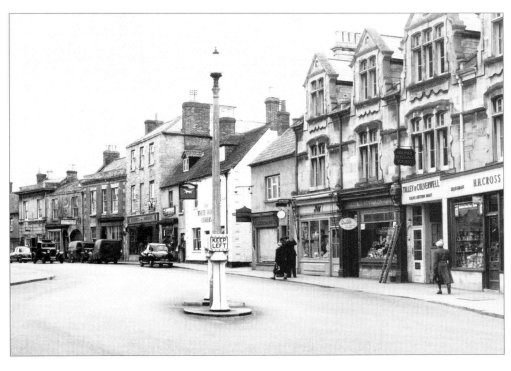

▲ WOOD STREET c1960 C228052

This part of Calne is unrecognisable now. Phelps Chambers, on the right, was demolished as part of developments in 1973. The White Horse public house (centre) at the corner of Zion Lane has been replaced by the new building at the entrance to the new shopping precinct, Phelps Parade.

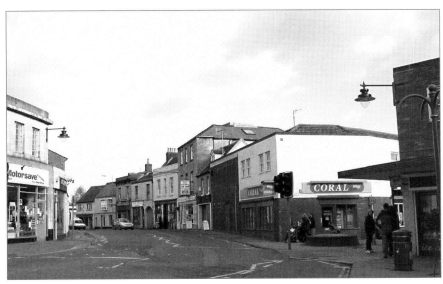

◀ WOOD STREET & PHELPS PARADE 2003 C228703

Richard Cowdy's bronze sculpture of the two pigs at the entrance to Phelps Parade was unveiled in 1979, four years before the closure of C & T Harris & Co. It was given by Calne Civic Society, and has become a popular landmark.

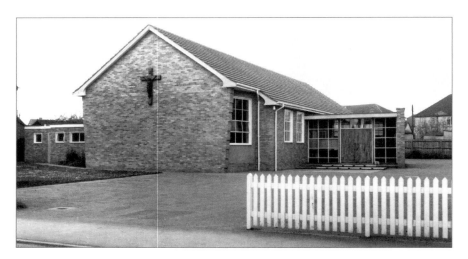

ST EDMUND'S CHURCH
c1965 C228119

Built at No 65 Oxford Road, the church was opened in 1964 after years of fund-raising. The need for a new Catholic church in the town became particularly pressing when nearby RAF Lyneham was unable to provide a full-time chaplain to the station, and they helped fund its completion. The church has a fine Stations of the Cross by the local resident sculptor Sean Crampton, installed 1986-87.

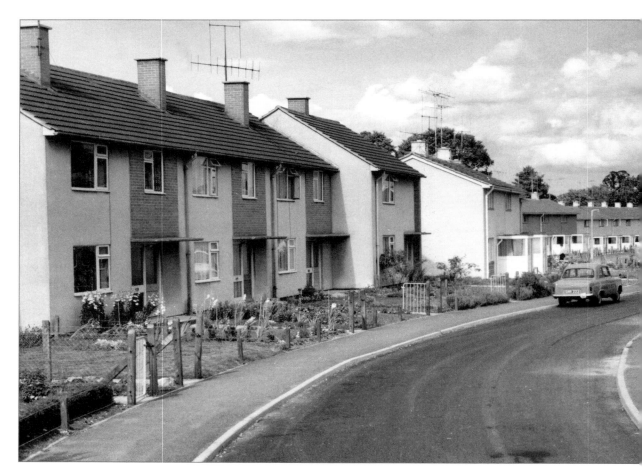

LESSONS AND LEISURE:

DEVELOPMENTS AROUND TOWN

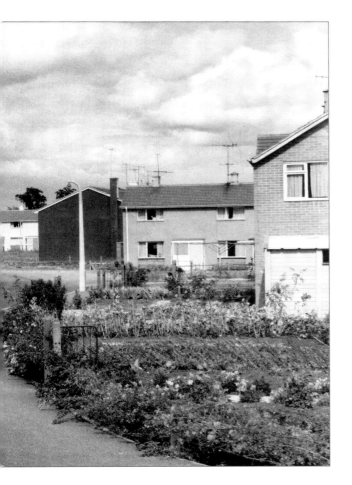

INTERESTING FACT

Calne attempted a world record with its Big Baton Challenge on 30 September 2003. Over 4,000 people passed a relay baton (a total of 4148 exchanges) over a distance of 35 miles within a ten-hour period.

NEWCROFT ROAD c1960 C228083

This view, taken with the Jenny Wren behind, looks east. According to the Wiltshire and Swindon Record Office, about 50 private houses were built in Bryans Close Road in the angle of North Street and Oxford Road in 1930. The borough council bought 21 acres of Newcroft Farm, off the east side of Lickhill Road, in 1954. By 1960 about 257 houses had been built in streets north of Bryans Close Road.

▼ **DOCTOR'S POND c1965** C228103

This footbridge, now gone, went across the river Marden from the footpath to the left, and led into a bungalow which was situated on what is now Somerfield's car park. Dr Joseph Priestley (1733-1804), who was librarian and tutor to the 1st Marquess of Lansdowne at Bowood, identified oxygen in 1774 and is commemorated here by a plaque.

▶ **THE RECREATION GROUND c1960** C228085

This view looks west, with St Mary's church tower just visible at the centre. Given by Alderman Thomas Harris to the town in 1891, the Recreation Ground at Anchor Road is about six acres. It includes a cricket ground with a pavilion, tennis courts and a bowling green, along with a children's play area. At the entrance a plaque commemorates local athlete Walter Goodall George who set the world record in 1886 for running the mile in 4 mins 12 ¾ seconds – a record unbroken for thirty years.

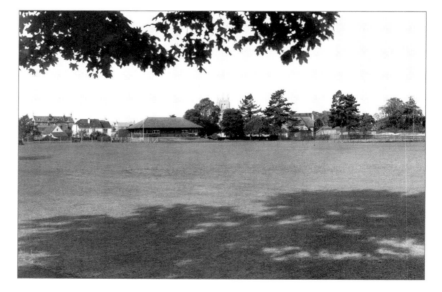

◀ **CASTLE STREET**
c1960 C228057

There are no remains of the supposed palace of the kings of the West Saxons which, according to John Britton (1801), gave this part of town its name. On the right behind the greenery is Castlefields House, former home of Edward Redmond, 1885-1907, now converted into flats. Next to the cottage, left, was the home of Dr Grant, who practised with Dr Rivett from 1948 to 1965.

▶ Taken from the programme for the Town's coronation celebrations of King George & Queen Mary, 22 June, 1911.

Event 5.—Hunt the Bellman. *Ditto.*

Event 6.—Barrel Race.
 First Prize 7/6 Second Prize 5/- Third Prize 2/6

Event 7.—Pillow Fight. *One Prize Only, 5/-*

Event 8.—Graceful Dive. *Ditto.*

Event 9.—Consolation Race.
 First Prize 7/6 Second Prize 5/- Third Prize 2/6

The Final Heats will take place at 4 p.m., when an Exhibition will be given by the Calne Swimming Club.

Special Sports Programmes will be on sale on Coronation Day.
The BANDS will play on the Wharf while the Sports are in progress.

———o———

CHILDREN'S
Monster Procession & Tea.

At 8.15 p.m. The Children will march from the Green, headed by one of the Bands, to the Strand, where the National Anthem will be sung, then to the Recreation Ground for Tea.

IN THE RECREATION GROUND,
At 6 p.m. There will be a

Maypole Pageant and Dance

by Girls and Boys of the Elementary Schools.
SYLLABUS :—

The Village School—the Village Beadle—a man in the stocks—old style sellers of children's toys—the Crier—invitation to the Coronation—joy bells.
Enter Heralds and Guards of Honor followed by the Queen and her Maids of Honor—Proclamation—Coronation—Dance.

———o———

Music & Dancing from 7 to 9 p.m.
also Refreshments, Cocoanut Shies, &c.,
in the Afternoon and Evening.
ADMISSION FREE.
The Ground will be closed at 9 p.m.

———o———

At 9.15 p.m.

A BONFIRE

will be lighted on the Green by the Mayor.

▶ **MARDEN COURT**
c1965 C228099

Marden Court, 'Elderly Folks Home and Grouped Flatlets for Elderly Folk', was opened in 1963. It was the first occasion in the south-west of England that both flats and a home were built together. It was built by the local builder G Hazell Ltd, and the cost, including land, was £51,132. Weekly rent for a flat was 40s 3d, and for the home £7 1s 9d. Current residents range in age from 71 to 101 years old.

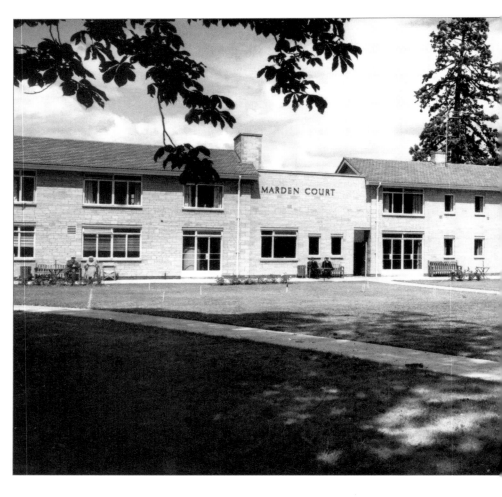

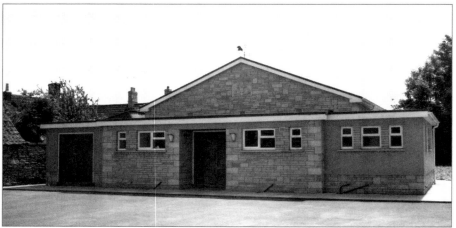

◀ **THE BOY SCOUTS'**
HALL c1965 C228097

The 1st Calne Scout group was registered in 1912, following its formation by RP Redmond. Their HQ was at Marden House until the war, and then they met at the Corn Exchange and Mill Street until the new hall was opened in 1962. It was built at the same time as Marden Court.

▲ CURZON STREET c1960 C228091

The lodge to the nonconformist cemetery built in 1867 can be seen on the bend of the A4 out of Calne. Before it is the entrance to St Mary's School, which moved from The Green in 1908. It now occupies a 25-acre site next door.

▼ ST MARY'S SCHOOL c1965 C228111

This building, known as the Matthews Block, was named after Miss Marcia Matthews, headmistress from 1923 to 1945. It was designed by the Chippenham architect Walter Rudman, and is currently used as the hall and dining room. Kay Stedman's book, *St Mary's School, Calne 1873-1986*, gives details of the construction by Blackford & Son: the building used '3650 cart loads of stone 75000 tiles cover the roofs' and 'the electrical installation has taken nearly three miles of wire and is the first scheme in Calne to be wired for the AC supply'.

BLACKFORD & SON 1950

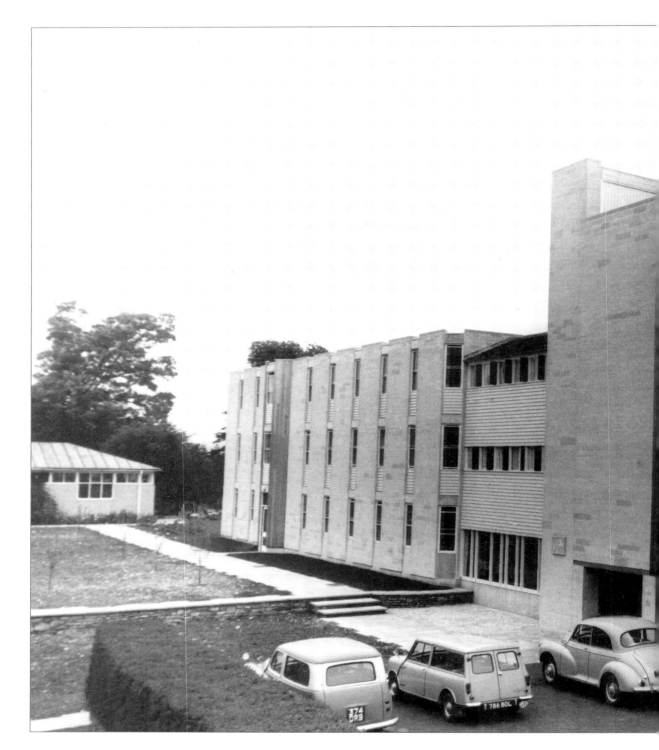

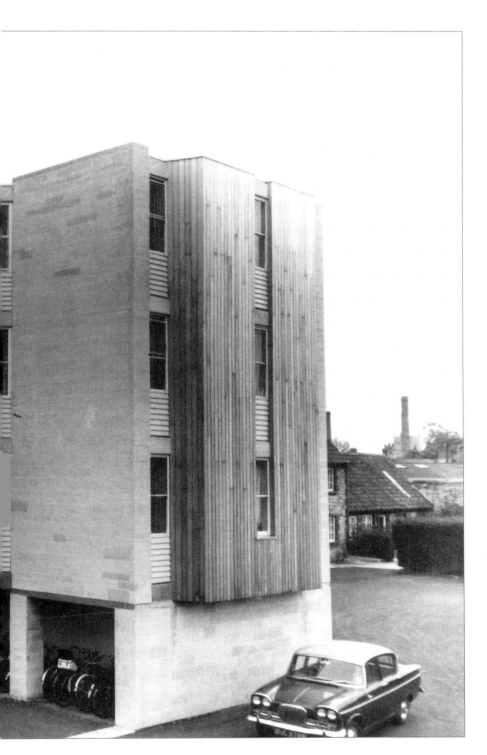

ST MARY'S SCHOOL
c1970 C228113

This boarding house, built in 1967, was named after Miss Betty Gibbins, headmistress from 1946 to 1972. Its modern design catered for the need for single rooms rather than dormitory-style ones. The newly-planted orchard, left, now has mature fruiting trees. Harris's chimney, far right, has gone.

S WILTSHIRE GROCERS INVOICE -1899

CHURCH STREET c1965 C228086

Wiltshire & Sons (left of photograph) opened their first supermarket in the 1960s, which later became Gateway in 1973. Beyond, on the corner with Mill Street, is No 26, Weston's, a stationers and newsagents, an earlier building re-fronted in the 19th century with a late Victorian shop-front. The weather vanes on the top of the pinnacles of the church were removed because they were unsafe.

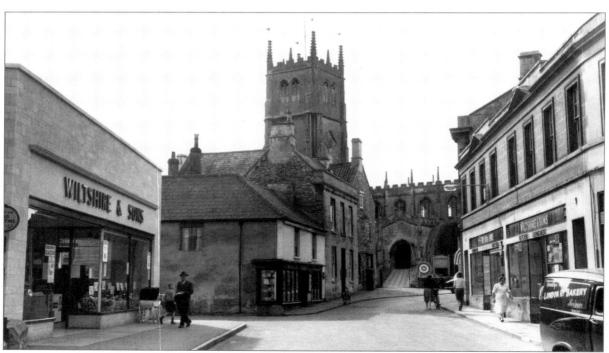

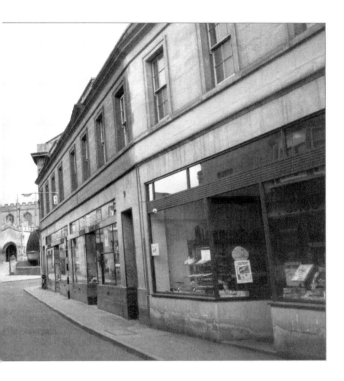

SAUSAGES AND SIDESMEN:
CHURCH STREET AND ST MARY'S CHURCH

▲ **CHURCH STREET c1960** C228066

The buildings on the right were re-faced after the Second World War by Harris's in neo-Georgian style. At No 23 is Rosa Lewis Cole, confectioner, and next door at No 24 is Wiltshire & Sons, butchers; their grocer's shop is opposite (left) at No 22.

THE CHURCH of St Mary the Virgin is a Grade I listed building of cruciform plan. Much of it is in Perpendicular style (although Norman features remain), and there are later additions. It stands in a raised walled churchyard with its four entrances at the compass points. There are distinctive paths of coral rag cobbles or flags (according to the *NWDC Conservation In Action Statement*). Tall yew hedges grow along the north and west paths, creating its distinctive look.

CHURCH STREET c1965 C228105

This view shows Calne Free Church, designed by the Warminster architect William Stent, behind Wiltshire & Sons. Next to Weston's (centre) is Gough's the solicitors, an 18th-century double-fronted building of limestone ashlar with a parapet. Next door is the end of Church House, a Grade II listed 17th-century building made of limestone rubble and ashlar dressings which was re-fronted in the 1720s; its roof was altered later. On the left, with the striped awning, is C & T Harris's retail shop, popular with locals.

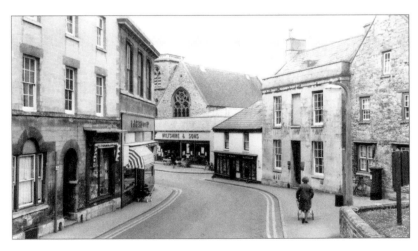

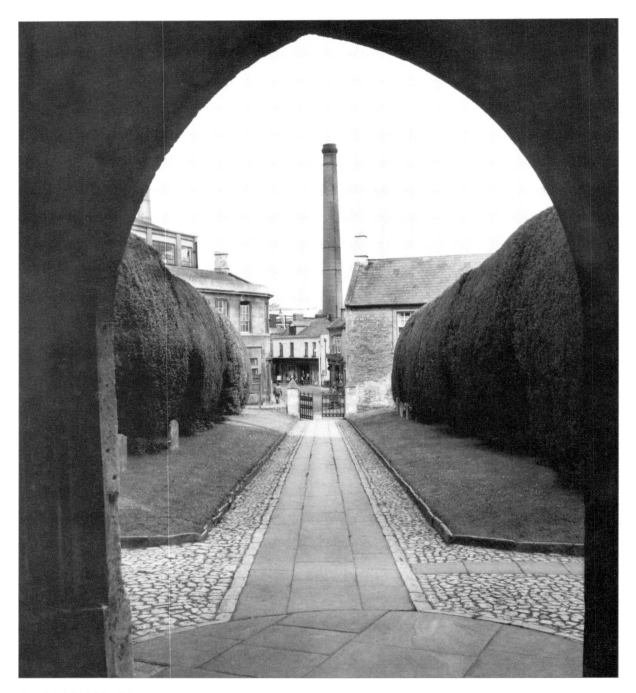

CHURCH APPROACH c1960 C228072

Harris's old boiler house chimney is prominent here, seen from the arched doorway of the north porch of the parish church of St Mary down past the fine well-clipped yews planted in 1865.

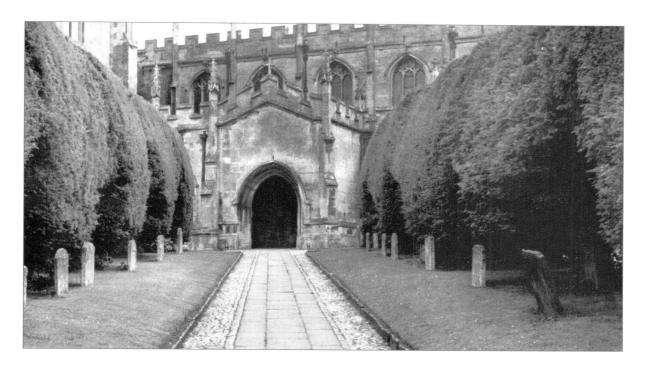

▲ ST MARY'S CHURCH c1955 C228014

This view of the north door shows the two-arched doorway with hood mould. Inside can be seen the remains of a Norman arch. The cobbles and flags are particularly fine features, and so are the yew trees.

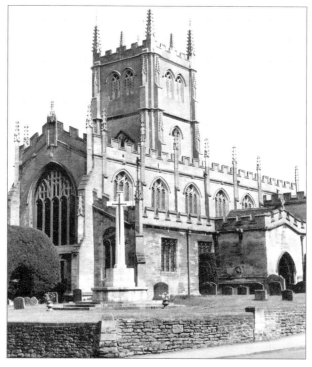

◄ THE CHURCH OF ST MARY c1955
C228033

The four-stage tower is described in the *Department of Heritage List* as having 'setback buttresses with attached pinnacles on the offsets, deeply moulded plinth and a crenellated parapet with corner pinnacles'. It houses a peal of eight bells which is rung every Sunday for morning services as well as for important events.

▼ **ST MARY'S CHURCH c1955** C228045

This shows the war memorial on the corner of Kingsbury Street which leads to The Green. Bessie Hacker of Heddington, a former Harris's employee, was awarded a certificate in December 2003 for her 60 years' continuous service as ringer. At one time all the ringers were Harris's employees and they were allowed to leave work to ring for weddings. However, their pay was docked - but the church made up their wages.

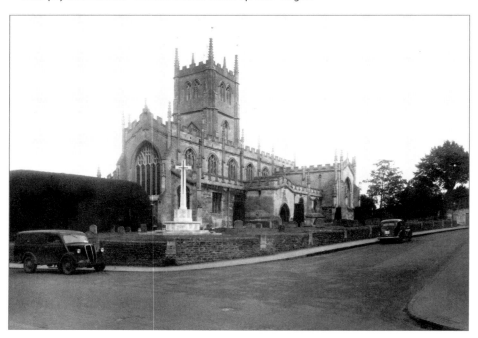

▶ **ST MARY'S CHURCH c1960** C228065

The church is famous for its four-manual organ (originally five) in 'the very large and sumptuous organ case' designed by C R Ashbee, who was also responsible for houses in Cheyne Walk, and made by the Arts and Crafts Campden Guild. It cost £2000 in 1908, when the Harris family donated it. It was fondly known as the 'Sausage Organ', and an appeal for its restoration was reported in the *Wiltshire Gazette & Herald* of 14 July 1960: £200 had been raised, 'a fitting opening to one of the biggest individual appeals ever organised at Calne – for £4000 for renovating and modernising the giant five-manual organ'. After decades of use, the hydraulically powered machine 'ran out of steam', and another appeal for restoration work, this time for £250,000, was launched in June 2002.

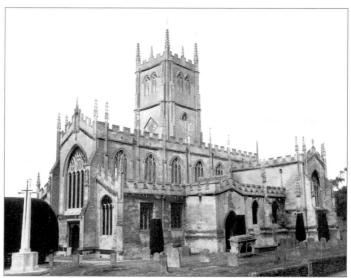

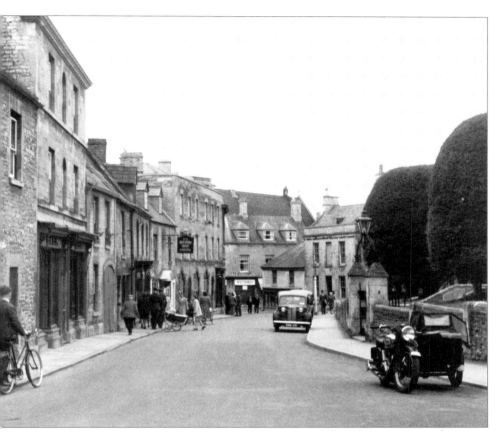

◄ **CHURCH STREET**
c1955 C228015

A stone stepped path (right) leads from the west of the church to the street. On the left side of Church Street, at No 29, stands the early 19th-century house and shop of G J Barnes & Son, ironmongers, now The English Rose beauty salon. Further along this row of Grade II listed buildings is the Butcher's Arms, 17th-century with early 19th-century alterations.

► **CHURCH STREET**
c1960 C228080

On the east side (right) is No 32, also known as The Pillars. It was once owned by the Harris family, and, at various times housed employees such as the resident nurse and Cecil Wilkins, the chauffeur. It is in fact a modest town house dating from the 17th century; it was re-fronted in the 18th century, and in the 19th century a portico was added to make it appear imposing.

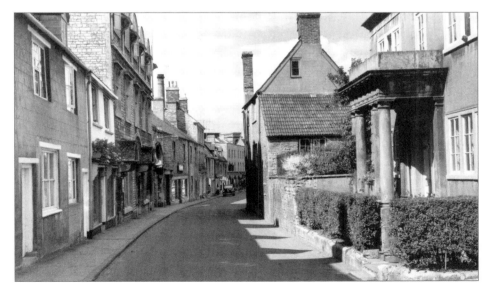

THE OLD ALMSHOUSES
c1955 C228018

These Grade II* listed almshouses at Nos 10-13 Kingsbury Street stand opposite the south entrance to St Mary's. They were erected by Dr John Tounson, vicar of Bremhill, in 1682. Originally built as eight houses in 'limewashed limestone rubble with ashlar ridge stone mullioned windows', in what Pevsner refers to as 'the local vernacular style', they were later converted into four larger units in the 1960s. The paired central heavy three-plank doors have strap hinges with fleur de lys ends. The grille-covered peep-holes are unusual.

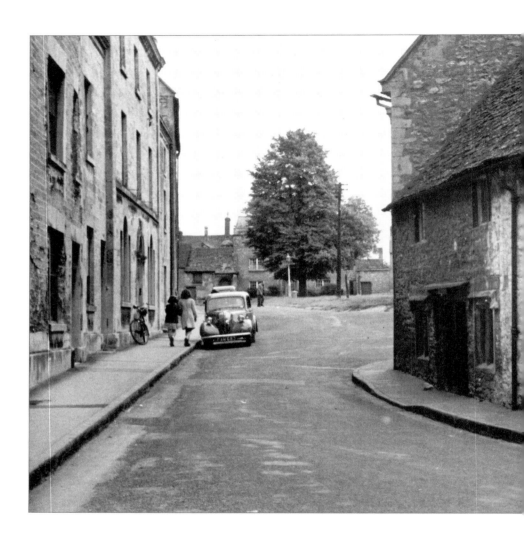

THE ALMSHOUSES c1960 C228075

It is hard to believe that in 1949 the Borough Council considered demolishing the almshouses. 'C O G' wrote in the pamphlet *Calne Civic Week Story of our Town* that 'the old Almshouses are in very bad shape and expensive to maintain. They fall far below modern standards'. He raised the problem 'whether to pull them down, preserve them as antiques, or provide others in their stead'. Thank goodness that they now appear on the *Department of National Heritage List of Buildings of Special Architectural or Historic Interest*, out of harm's way. The inscription plaque in the far left wall is worth reading.

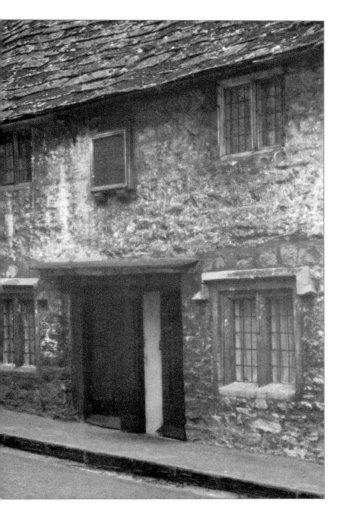

A PLACE OF MATERIAL WEALTH:

THE GREEN

FORMERLY KNOWN as Kingsbury Green, this area is one of particular historical interest comprising mainly listed buildings. Pevsner describes this part as 'a spacious triangle with the wealthiest houses of Georgian Calne, and now the only really attractive part of town'. During the centuries of cloth making, The Green was the centre of the industry. Former workshops and the houses of the wealthy clothiers bear witness to this. At one time The Green boasted a number of alehouses (one is still remaining in picture C228125, page 58), and when A E W Marsh was writing his history of the town in 1903, it was the educational centre of the town, with five schools located there.

THE GREEN c1955 C228019

On the south side is a fine group of listed buildings. No 17, left, dated 1894, was built as a technical school and has served as a primary school and Masonic hall. The pair of 16th-century houses at Nos 19 and 20 originally formed a continuous range with the White Hart Hotel (far right), and were re-fronted around 1758. Priestley House, centre, is where Joseph Priestley stayed from 1772-1779 whilst working at Bowood.

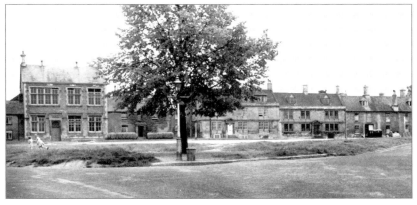

▶ **THE GREEN c1950**
C228020

The north-western corner is a continuation of Kingsbury Street, and the parish church of St Mary dominates the view. The first houses on the right, Nos 6 and 7, were originally one house dating from the mid 15th century; the medieval timber roof construction still survives.

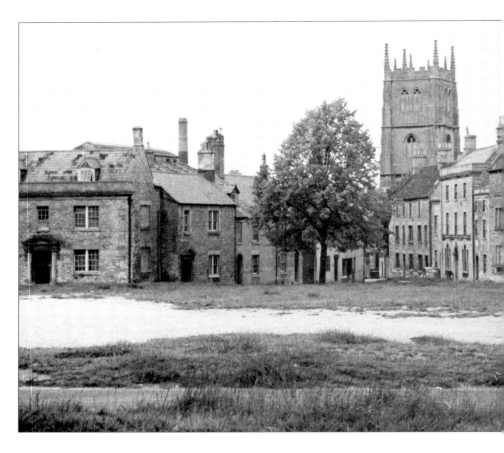

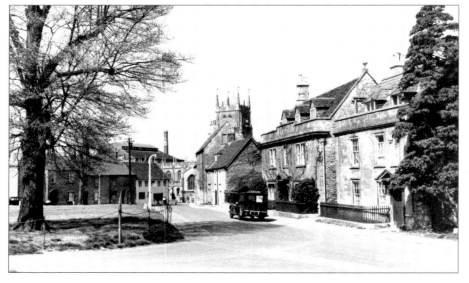

◀ **THE GREEN c1955**
C228032

On the right with the railings are two fine examples of clothiers' houses from the mid 17th century, re-fronted and altered in the late 18th century. Sheldon House, second on the right, was the home of the Bailys, a leading clothier family. (Their memorial tablet can be seen in Calstone church.) It dates from 1656, and has attractive pilasters, cornices and parapet features, and a coped gable with a right-hand ball finial.

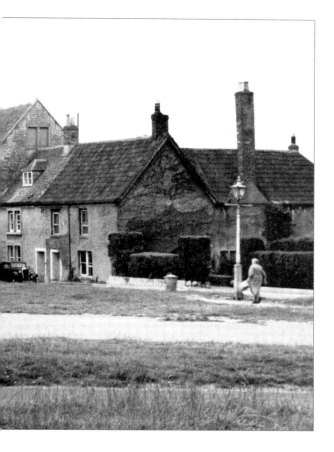

INTERESTING FACT

In 1977 the composer Sir Michael Tippett, who lived locally, was interviewed by David White, Head of Music at The John Bentley School, as part of the Calne Music Festival week at the FE Centre on The Green.

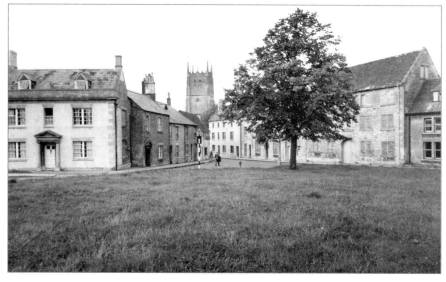

◄ **THE GREEN c1955**
C228062

Unfortunately, The Green today is not as traffic-free as in this picture. No 30, left, is an attractive early 19th-century double-fronted house with a Roman Doric pedimented porch. Miss Ellinor Gabriel bought the house in 1873 for the first St Mary's School, founded by Canon John Duncan, and started with six day girls and three boarders.

▼ **THE GREEN AND THE CHURCH c1965** C228125

Centre left at No 33 is the Green Dragon, a cider house, which closed in the late 1960s. On the right is the late 18th-century Weaver's House, which probably housed machinery for carding and spinning wool. It was bought by Harris's to store sawdust for smoking their bacon; their supplies came from W E Beint & Sons Ltd, whose sawmills at Studley were famous for making elm coffin boards and pit props for the mines in Wales. The Weaver's House was converted into flats in 1975.

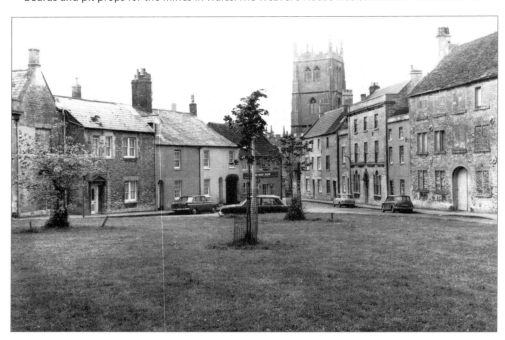

▶ **THE WHITE HART HOTEL c1965**
C228123

This view of the Grade II* listed White Hart Hotel was taken from South Place at the junction with The Green and the A4 London Road. The whole of the building was rebuilt above the basement between the 17th and the 19th century, and in 1828 a raised portico was built. On the opposite corner is the former National School for Boys, dated 1829. Don Lovelock remembers his school days here - it was then part of Calne junior school: 'The windows were so high you couldn't look out. It was somewhat depressing sitting there, chanting your times table.'

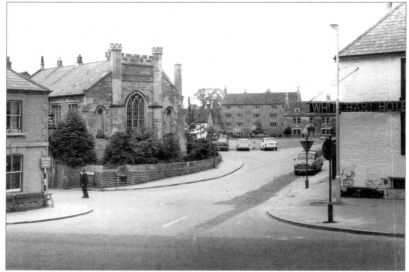

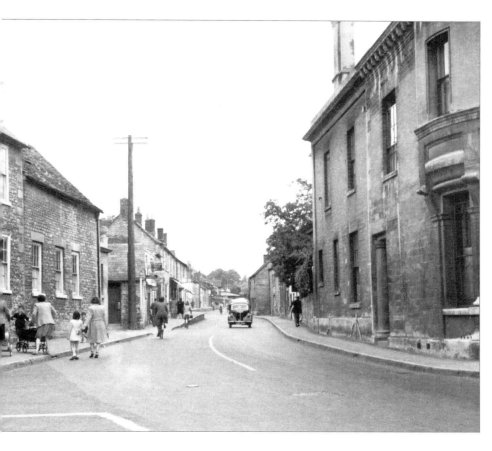

◄ LONDON ROAD
c1955 C228023

On the right is South Place, former home of members of the Harris family, which became the surgery of Dr Grant in 1947. He later formed a partnership with Dr Rivett, and they practised here until the premises were demolished in 1962 to make way for road and housing developments.

► LONDON ROAD
1965 C228100

This view, looking from the corner of Silver Street and London Road, shows the site of South Place, with the White Hart opposite. The King George public house, centre, was built in the mid 19th century in the angle of New Road and the old Back Street, now Church Street.

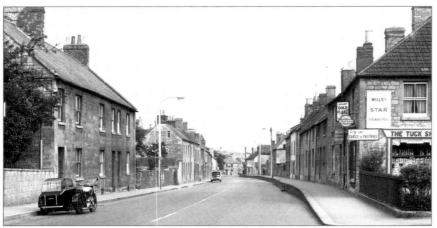

LONDON ROAD c1960
C228056

This view was taken at the corner of Shelburne Road (right), and looks towards the town. The Tuck Shop on the right was a grocers run by Ernest Kethero.

OUT OF TOWN AND EASTWARDS:

QUEMERFORD, CHERHILL AND COMPTON BASSETT

LONDON ROAD c1955
C228017

This traffic-free view towards town is now a very busy road. The 19th century houses are generally rendered. The different levels of the roofs make an interesting skyline, and the raised pavement on the east side (right) separates the pedestrian from the traffic - but it makes parking close to the kerb difficult.

E H KETHERO FROM TOWN GUIDE 1966

MAY WE SERVE YOU?
E. H. KETHERO
GROCER & PROVISION MERCHANT
LONDON ROAD,
CALNE, WILTS.
Telephone: Calne 3103

invites your enquiries and will value your custom

Town Deliveries Daily

▼ WESSINGTON AVENUE c1955 C228073

Known by locals as 'The Cages', the three rows of lime trees were planted on the north east side of the road in the early 1840s. The road was called Wessington Avenue to make the approach from London more impressive. The mock-Tudor building (left) is the former offices of Blackford & Son, builders. The terraced houses were built about 1906.

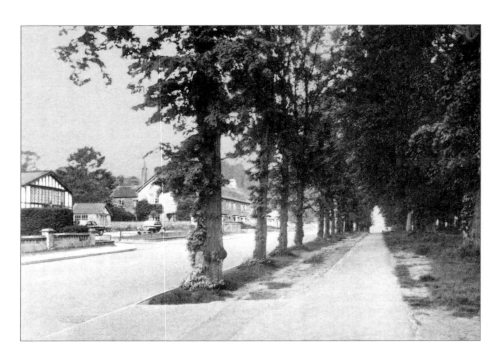

► HOLY TRINITY CHURCH c1960 C228093

The church of the Holy Trinity is set back from the London Road in a graveyard bounded by the trees of Wessington Avenue. It was built in 1853 as a chapel of ease to accommodate the growing town congregation, and also to replace St Mary's churchyard. Built of coursed, squared limestone rubble in Gothic Revival style, it has a chancel with a north vestry and a nave with a south porch; the west bellcote has an octagonal spirelet.

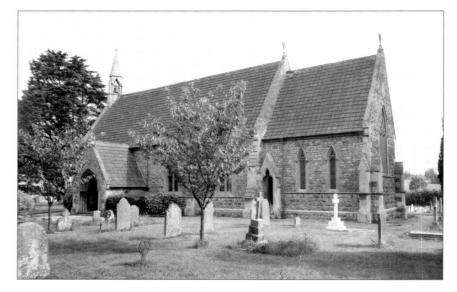

◄ BENTLEY GRAMMAR SCHOOL c1965 C228115

Through the 1662 legacy of John Bentley, a free school was founded on The Green. A new grammar school was built on the site at Wessington in 1957, the first in the county of Wiltshire, with 360 places for boys and girls. It has grounds of about 35 acres, with splendid views of the Downs and the White Horse. It became a comprehensive in 1974, merging with the Fynamore Secondary Modern School. Further developments in the late 1990s, when the school became a single-site, have transformed this view.

HARRIS'S INTERESTING FACT

Calne pop group The Pack reached No 27 in the UK charts with *Do You Believe in Magic?* in 1965. The school friends Brian Gregg, Rod Goodway, Roger Hartley, Bob Duke and Andy Rickell were discovered by pop impresario Micky Most, who lived in Wiltshire at the time.

▼ **QUEMERFORD, LOWER QUEMERFORD MILL c1955** Q6005

Taken opposite Lower Quemerford Mill, this view shows Marden Bridge and the Mill House on the right. Originally fulling mills, the Quemerford mills were rebuilt as a water-powered cloth factory in c1800. At its peak in 1836, this mill was producing 50 ends of broadcloth a week. In 1841 it was converted to a grist mill. It was owned by Messrs Pound Bros but has now been converted into residences and businesses.

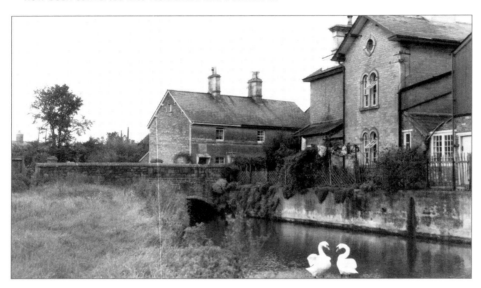

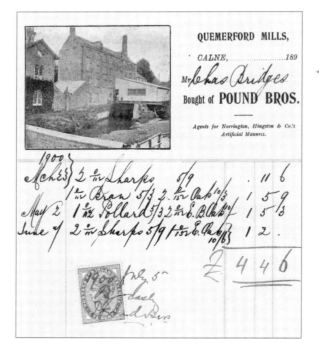

◄ **POUND BROS INVOICE QUEMERFORD MILLS 1900**

◄ QUEMERFORD, THE VILLAGE c1955
Q6004

No 73, Quemerford (first left) used to be a paper shop run by Sidney Horton. The Wall's ice cream sign at No 125 is at Webber's, the grocers. Don Lovelock recounts how children used to rattle the corrugated iron extension as they passed.

► QUEMERFORD, THE VILLAGE C1955
Q6001

The sub-post office for Calne was established here at No 171 in 1935. These 19th-century cottages along the main road were probably built for workers at the Upper and Lower mills nearby.

▶ **CHERHILL,
THE WHITE HORSE AND
THE MONUMENT c1955**
C770049

This view can be seen from the A4 road to Marlborough. Situated on the edge of the Cherhill Downs, just below the earthworks known as Oldbury Castle, this is the second oldest of the Wiltshire white horses. It was cut in 1780 under the instructions of a local physician, Dr Christopher Allsup. The shape was marked out with a series of white flags, which were positioned under his instructions shouted through a loud-hailer. It is 123 feet wide and 131 feet high, with 8000 square feet of chalk exposed. Nearby is the 125-foot Lansdowne Monument, an obelisk designed by Sir Charles Barry and erected by the 3rd Marquess to commemorate his ancestor, the economist Sir William Petty. It was renovated by the National Trust in 1990.

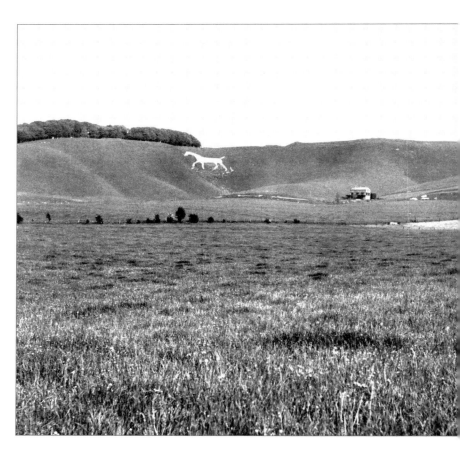

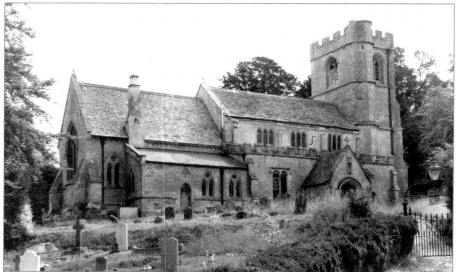

◀ **COMPTON BASSETT,
ST SWITHIN'S
CHURCH c1955**
C696001

The parish church appears quite imposing on its elevated position. Some 12th-century parts survive, but it is externally 15th-century, with chancel and side chapels of 1865 by Henry Woodyer, who was also responsible for the fountain in the Market Place at Devizes.

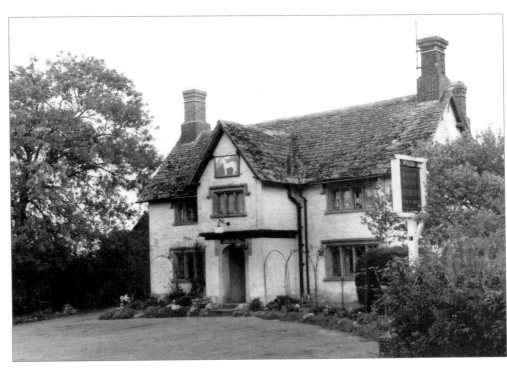

▲ **COMPTON BASSETT, THE WHITE HORSE INN c1955** C696004

An unusual claim to fame for this place, originally built c1850, is Terry Waite's visit in 1991 for his first pub meal on UK soil after landing at RAF Lyneham on his return from the Lebanon, where he had been held hostage for 1,763 days.

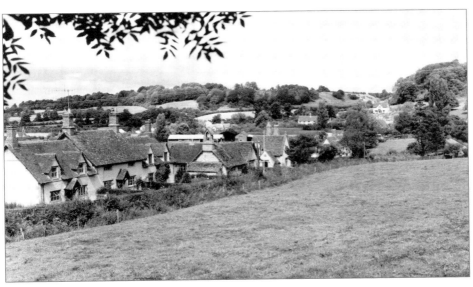

◄ **COMPTON BASSETT, GENERAL VIEW c1960** C696002

A E W Marsh describes the village as 'the prettiest for miles around'. This view shows the main street with the Old School, centre, which closed in 1964. RAF Compton Bassett was built on farmland mainly in Calne and Cherhill parishes, and operated from 1940 to 1964.

BECKHAMPTON
THE HOUSE AND THE RACING STABLES c1955 B292014

We are on the A4 road to Marlborough, looking towards Calne. At this point there is now a major roundabout which takes traffic right to Avebury, or left to Devizes. Beckhampton House and stables, on the left, are currently owned by Roger Charlton.

BECKHAMPTON
THE WAGON AND HORSES INN c1955 B292013

This popular pub for local jockeys and trainers from the nearby stables has changed little, apart from the spelling, which is now 'Waggon'. The author remembers eating there in the 1970s, enjoying the mystery dish on the menu called 'Pig in the Poke'. The petrol station opposite, once owned by Frank C Harcombe, according to *Kelly's Directory of Wiltshire 1939*, is now a parking area.

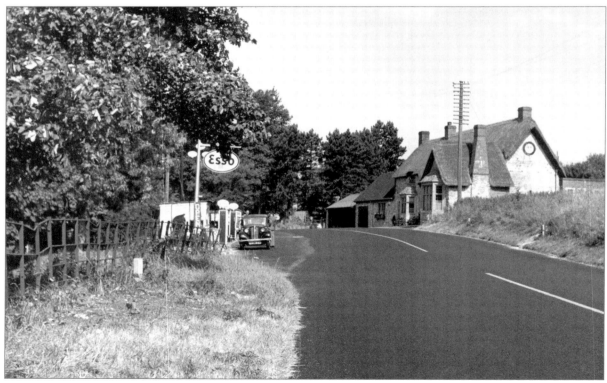

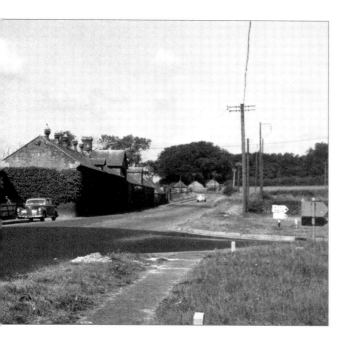

OF HORSES, HILLS AND HENGES:

FROM BECKHAMPTON TO AVEBURY

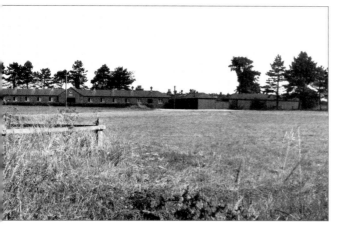

BECKHAMPTON, BECKHAMPTON STABLES c1955
B292016

This view looks north from the house and main stables across to Top Yard, the stables and exercise area built in 1927. After a particularly successful year, Fred Darling built eleven individual wooden cage-boxes, each centrally heated, with porcelain mangers and tiling - no expense spared at £1200 each.

IN 1908, in his *Round About Wiltshire*, A G Bradley wrote an idyllic description of the five mile 'run' between Beckhampton and Calne: 'One is on the wide open down, traversing the north-western slope of the chalk country. To the left are round barrows breaking the now contracted sky line, the wandering bunches of sheep, the wheeling plovers, the friendly white-tailed wheatears, and the skylarks innumerable filling the air with song'. Now you are as likely also to see race horses being exercised on the 500 acres of Wiltshire downland belonging to Beckhampton Stables.

During the sixty years of family business from 1880, the former coaching inn turned stables of Sam and Fred Darling have produced seven Derby winners, four St Leger winners and nine other winners of classic races. In 1932, Gordon Richards began riding for Fred Darling, the leading trainer of his day. They were so successful that Richards clocked up 259 wins, beating the record previously held by Fred Archer since 1885.

The road to Swindon from Beckhampton passes through Avebury village and the Neolithic stone circle and henge (bank and ditch). It was built from 2800 BC onwards, and is considered one of the most important megalithic monuments in Europe. It is a Scheduled Monument, owned by the National Trust and protected by English Heritage. Along with Silbury Hill, it is a World Heritage Site. It was recently voted the nation's third most spiritual place.

INTERESTING AVEBURY FACT

It took Alexander Keiller four days and twelve men to raise one stone using the Neolithic method of levers, timbers and man-power.

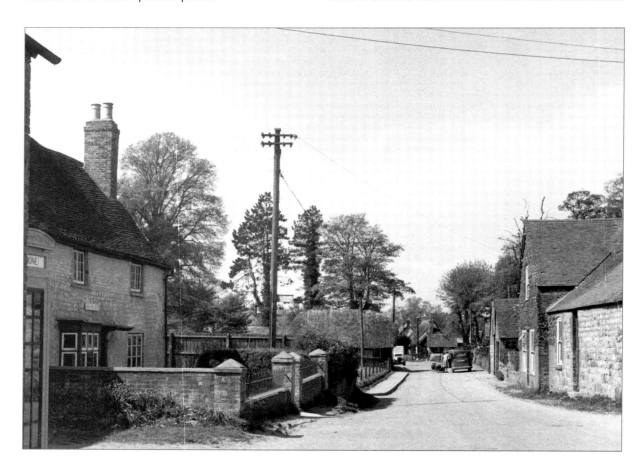

AVEBURY, THE HIGH STREET c1950 A80008

This view looks from within the circle, west to the High Street which continues outside the henge. The post office (left) is now a Celtic gift shop. The walls have gone, and cobbles found in the rear garden have been laid at the front. On the right is Manor Farm, now a residence and bed and breakfast.

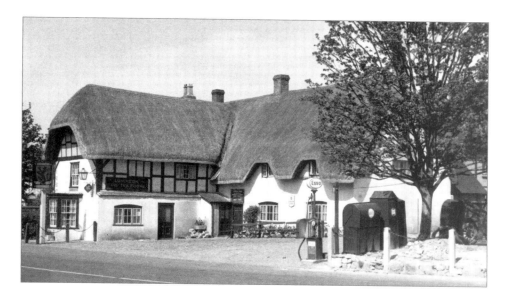

AVEBURY
THE RED LION
c1955 A80006

The foundations of this building were laid in the early 17th century, but it did not become licensed premises until 1822. The forecourt has changed to accommodate parking - the tree, the petrol pumps and the oil dispensers have been removed. It has recently been re-thatched and sympathetically restored.

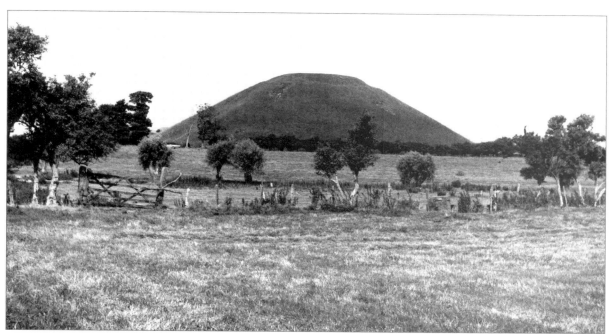

AVEBURY, SILBURY HILL c1955 A80011

Silbury Hill is about 4,500 years old and is the largest prehistoric artificial mound in Europe, standing at 130 feet. Apart from a core of gravel, clay and soil, it is made entirely of tightly rammed chalk, excavated from the ground around. It is also a Site of Special Scientific Interest, which protects the earth from erosion. The public are not allowed to climb the hill in order to preserve its unique downland flora, as well as for safety reasons. (The author remembers climbing the hill after a night out with friends at the Wagon and Horses in the mid 1970s and sliding down the slope on her bottom!)

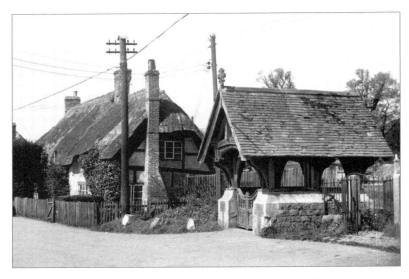

AVEBURY, THE OLD COTTAGES AND THE LYCHGATE c1955 A80010

The lychgate entrance to St James' church is a fine roofed wooden gateway built in 1899. Designed by Charles Ponting of West Overton, who was also architect and surveyor for Marlborough College, it was built by the Ponting Brothers of Avebury, along with the Shipway (masons) and Paradise (ironworkers) families. The chimney and wall on the old bakery (left) were removed when the wall collapsed under the weight of the ivy, and a new extension was built.

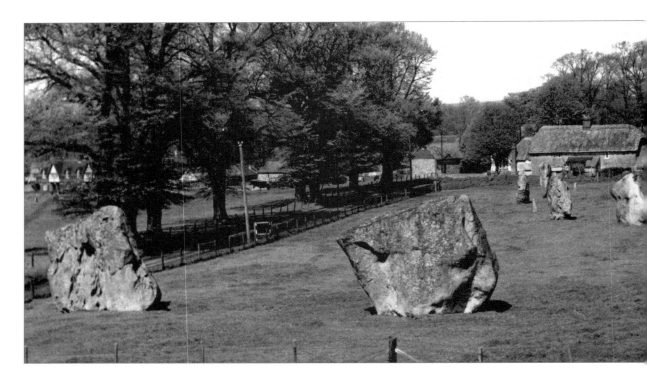

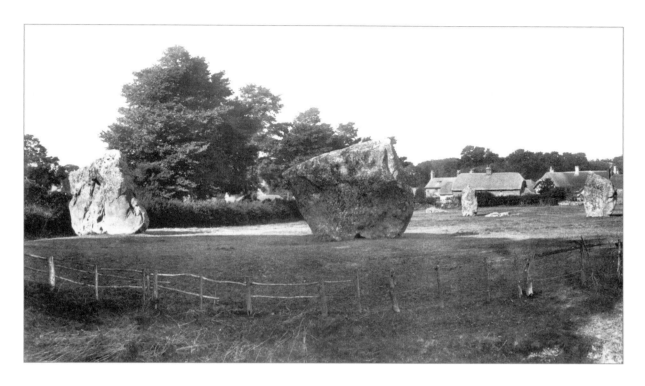

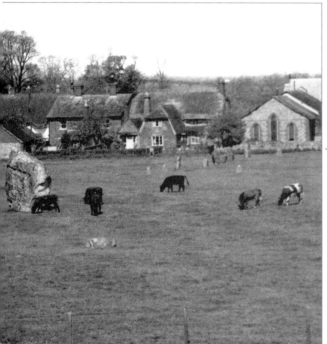

▲ **AVEBURY, THE STONES 1899** 44859

This photograph shows the southern portal entrance with the Devil's Chair to the left; in the distance (right) are two stones left standing of the southern inner circle. Alexander Keiller, heir to the Dundee marmalade fortune, gradually purchased the site of Avebury and the West Kennet Avenue. He was responsible for excavation and restoration work on the stones in the 1930s.

◄ **AVEBURY, THE STONES c1955**
A80019

This shows the south-east sector with the five restored stones completed by Keiller by 1939. Recent archaeological investigations by The National Trust have revealed an arc of at least 15 stones buried in the circle itself. Although they do not have immediate plans to raise them, they may be able to create 3-D computer images of the stones using ground–probing radar, and thus 'raise' them virtually.

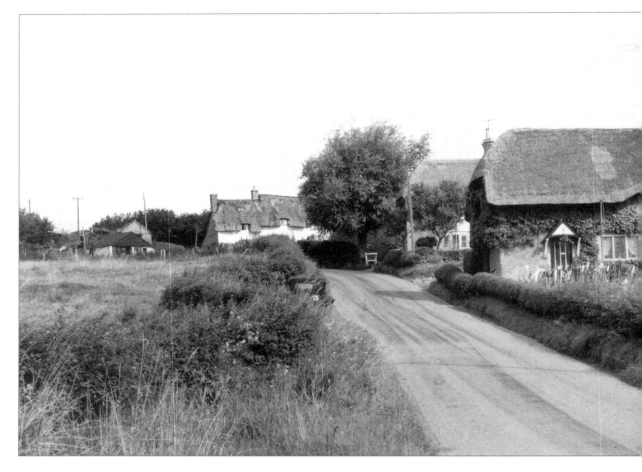

COTTAGES AT RATFORD c1960 C228092

These cottages on Ratford Hill are similar in style to the Sandy Lane estate cottages. The pair on the right was built in the early 19th century for Bowood estate workers. The half-hipped roofs have recently been attractively re-ridged with the addition of decorative pheasants.

HAZELAND MILL c1965 C228117

Now a private residence, this was originally part of the estates of Malmesbury Abbey in the 16th century, according to K Rogers in '*Wiltshire and Somerset Woollen Mills*'. It was a cloth mill until c1835, and a grist mill until c1965; at this time it was owned by Chas T Pavy, who dealt in 'pure barley-meal, offals and corn seed'. It was worked by a turbine rather than a wheel.

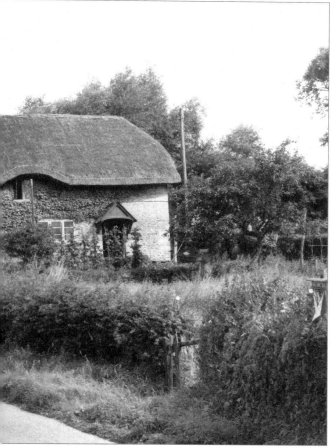

OUT OF TOWN AND WESTWARDS:

BREMHILL, BOWOOD AND DERRY HILL

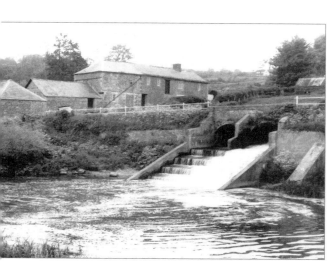

HAZELAND MILL INVOICE

▼ BREMHILL, THE CROSS, THE CHURCH AND THE SCHOOL c1960 B375001

The parish church of St Martin is described as 'Anglo-Saxon origins, c1200, C13, C15, restored 1850' (*Department of Heritage List*). The former school, now the village hall, is dated 1846. Jean Lovelock (née Dennis), who lived behind the playground, was at the school in the late 1930s. She remembers the two classrooms with old paraffin lamps and tortoise stoves which 'used to get red hot so we burned in the front and shivered in the back'.

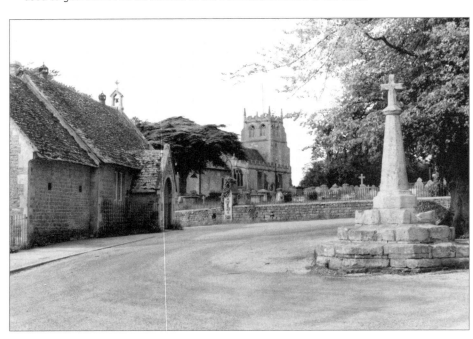

▶ BREMHILL THATCHED COTTAGES c1960 B375002

The roof of No 10, left, is now tiled, and Nos 11 and 12 have been re-thatched. Leslie Fry, whose family were bakers in Bremhill (they also had a shop in Calne), was born in No 12 in 1915. He remembers the blacksmith's next door with its two forges.

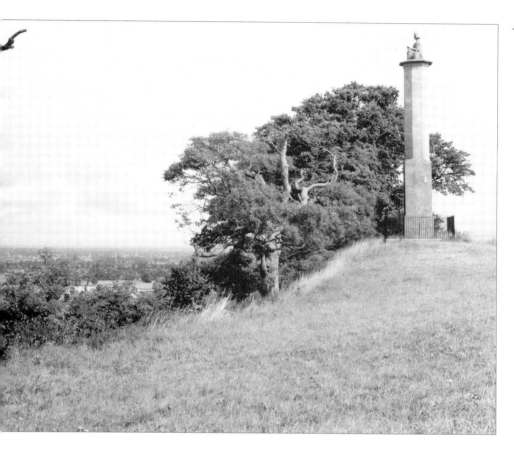

BREMHILL, THE MAUD HEATH MONUMENT c1960
B375004

The rustic seated figure of Maud Heath gazes down from her lofty monument overlooking Dauntsey Vale. It was erected in 1838 'at the joint expence of Henry Marquis of Lansdowne Lord of the Manor, and Wm L Bowles vicar of the parish of Bremhill'. It commemorates the pedlar woman who left money in 1474 to create a road and causeway for journeys to market in Chippenham.

BREMHILL, INSCRIPTION STONE, WICK HILL c1960
B375008

The inscription on the other side of the road reads: 'From this Wick Hill begins the praise/Of Maud Heath's gift to these highways'. The Causeway runs the four and a half miles from Wick Hill through Tytherton, crossing the disused Wilts and Berks Canal, across the Avon to Kellaways, through Langley Burrell and into Chippenham at Langley Road.

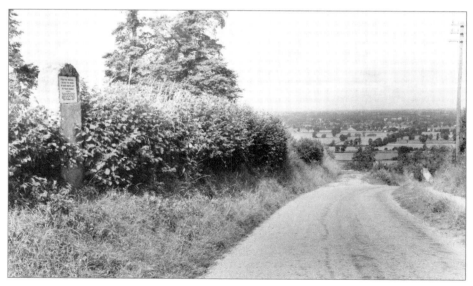

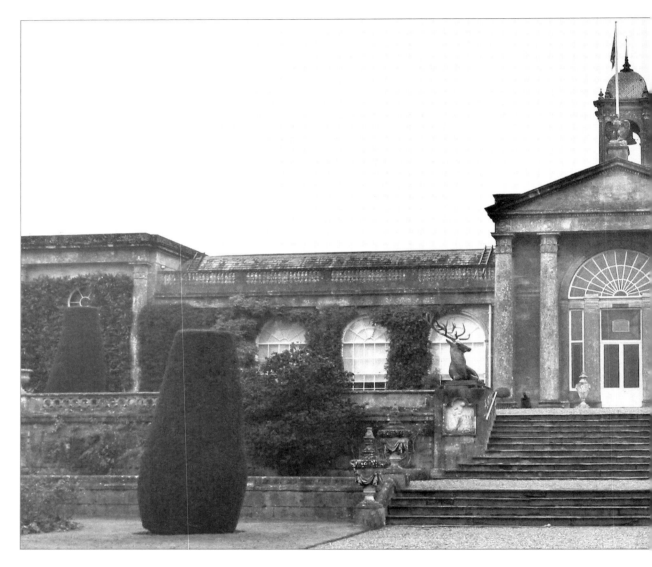

BOWOOD HOUSE 2003 C228704

This view shows the Adam front, the orangery, the terrace and the parterre, with the family rooms on the right. The upper terrace (by Robert Smirke, who designed the British Museum) was originally completed in 1818. The magnificent stags are by Geiss of Berlin, 1852. By 1857 Italianate gardens had been laid out on both terraces. The yews were planted in about 1900.

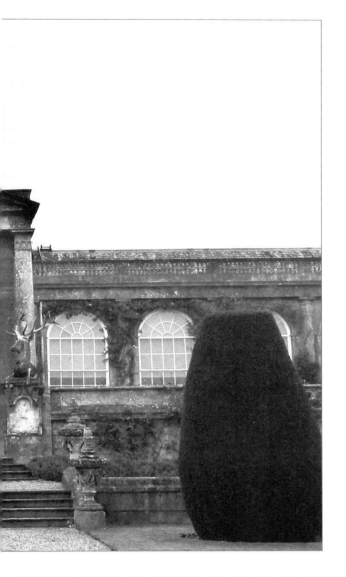

BOWOOD is the seat of the 9th Marquis of Lansdowne who took over the estate in 1972 and opened it to the public in 1975. The original house was built in about 1727 by Orlando Bridgeman; extensive improvements were made by Henry Keene between 1754 and 1761, and by Robert Adam who built the orangery wing. The library wing and the chapel were redecorated in the early 19th century. During the 18th and 19th centuries, the house was host to many noted literary and political figures. Dr Joseph Priestley, who discovered oxygen gas at Bowood in 1774, and Dr Jan Ingen Housz, who discovered the process of photosynthesis in 1795, worked in the laboratory, now an anteroom to the ibrary.

The main house was known as the Big House, and the east wing of the service buildings as the Little House, but in 1955 the Big House and its linking building were demolished. A headline in the *Wiltshire Gazette & Herald* for 11 August 1960 proclaims:' Queuing up at Bowood for helicopter trips - Takings at mammoth fete in region of £1000'; the article describes the first public function at Bowood since the demolition of the Big House. Speedboat trips, demonstrations by the fire service and £1 trips in a helicopter helped to raise money for Derry Hill Church.

INTERESTING BOWOOD FACT

Lady Bird Johnson visited Bowood House in c1980, staying in Buck Hill House on the estate. Drivers from Cyril H Thomas's, motor dealers, Calne, went through rigorous checks by the police, and then by the CIA, before being hired to drive the President's wife and entourage around during the visit. It was so hush-hush that no-one knew in advance who the visitor was or when he or she was due.

DERRY HILL, THE GOLDEN GATE
2003 D706701

This imposing Grade II* listed entrance now leads to the Bowood Golf and Country Club. It was designed by Sir Charles Barry, architect of the Houses of Parliament. The arch and belvedere (small look-out tower) were built c1845 across the entrance to the park on or near the site of the old Lansdowne Arms (formerly the Shelburne Arms - a new Lansdowne Arms was built opposite in about 1834). This asymmetrical composition - a 'balustrade triple gateway flanked by high campanile tower to right and small Italianate lantern to left' - is an important example of the 19th-century Italianate style.

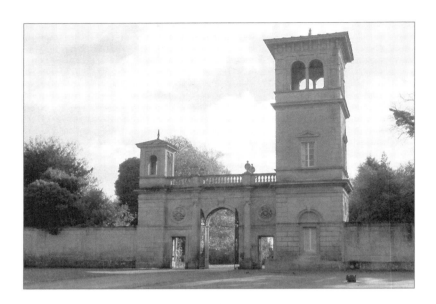

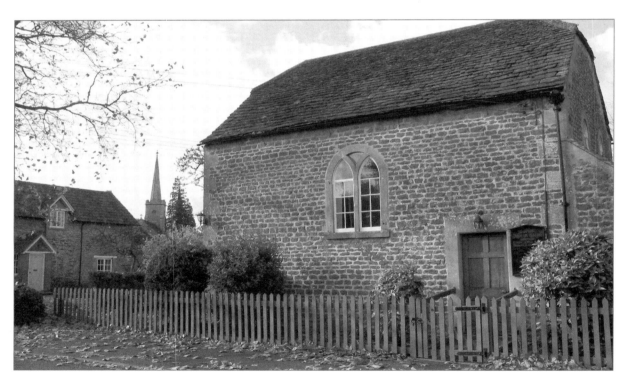

DERRY HILL, LITTLE ZOAR CHAPEL 2003 D706702

The east side of the Strict Baptist Chapel has a door with the inscription 'Little Zoar 1814'; Zoar is the Old Testament name of a city on the Dead Sea. It is a charming little rectangular building with the one central arched Y-traceried window.

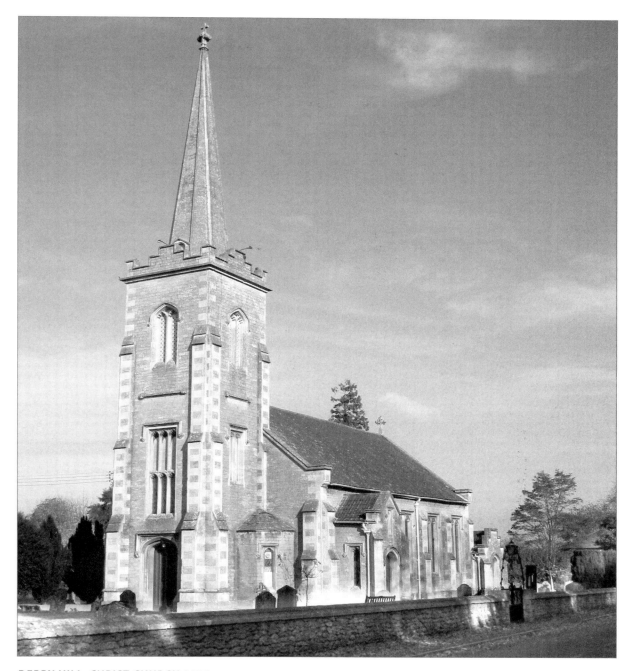

DERRY HILL, CHRIST CHURCH 2003 D706703

This church was built primarily as a chapel of ease for Bowood Estate workers who lived in Derry Hill and Stanley. It was designed by T H Wyatt and D Brandon 1839-40, and paid for by money raised locally. The spire was donated by the 3rd Lord Lansdowne at a cost of £11 10s 0d.

LACOCK, PORTRAIT OF FOX TALBOT, LACOCK ABBEY C1955 L1015

This portrait, painted by Anna Zinkeisen in the 1950s, was commissioned by the Royal Photographic Society, but then given to the family. It now hangs in the Fox Talbot Museum. It was based on a daguerreotype by Antoine Claudet of 1845-46. Using a different background, this portrait shows William Henry Fox Talbot holding his portable camera obscura and lens cap.

INTERESTING LACOCK FACT

Fox Talbot, who discovered the negative/positive photographic process in 1835, was also one of the few men in Britain able to read cuneiform. He published translations of inscriptions by Assyrian Kings, some of whose palaces had been discovered in 1847.

SANDY LANE, THATCHED COTTAGES 2003 C228705

Copse Cottage (centre) is one of the Grade II listed cottages which form part of what is described as 'an outstanding example of an estate village in the picturesque manner' (*Department of Heritage List*). They were built for Bowood estate workers in the early 19th century to replace ones lost when Capability Brown redesigned the gardens and grounds.

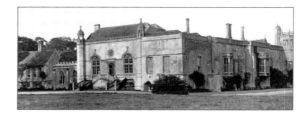

LACOCK, LACOCK ABBEY c1955 L1010

The main entrance to Lacock Abbey, with its double flight of steps and two tall ogee-headed windows, is an early example of the 18th-century Gothic Revival. Sharington's Tower (right) was the strong room for valuables, and its ornamented balustrade is noteworthy. The oriel window on the right is famous as an image captured in Fox Talbot's earliest surviving negative, taken in 1835. The 14th- and 15th-century cloisters have a new fame as the setting for Hogwarts in the Harry Potter films.

A PHOTO FINISH:

SANDY LANE, LACOCK AND BROMHAM

SANDY LANE, along the Chippenham to Devizes road, was built on Lower Greensand, and had been given its name by 1675. This picturesque hamlet was designated a conservation area in 1974. The once-humble estate workers' cottages are now much-sought-after residences, with thatching and historical features maintained to a high standard; some pairs have been knocked into one. The near-by National Trust village of Lacock is a popular place for tourists all year round, even more now with its connections with the filming of *Pride and Prejudice* and *Harry Potter*.

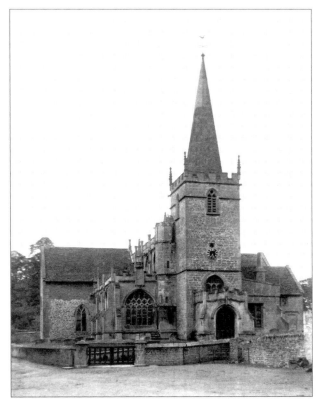

LACOCK, THE CHURCH OF ST CYRIAC c1955
L1007

This is the only church in England dedicated to St Cyriac alone – he was a child martyr of the 3rd century. Pevsner writes: 'Except for the transepts, a Perp church, and an impressive one internally and externally'. The porch is interesting, with 'battlements and a tierceron-vault with bosses' - extra decorative ribs spring from the corners of each bay. In the Lady Chapel is the tomb of Sir William Sharington, one of the first lay owners of Lacock Abbey; it is one of the finest mid 16th century decorative monuments in England.

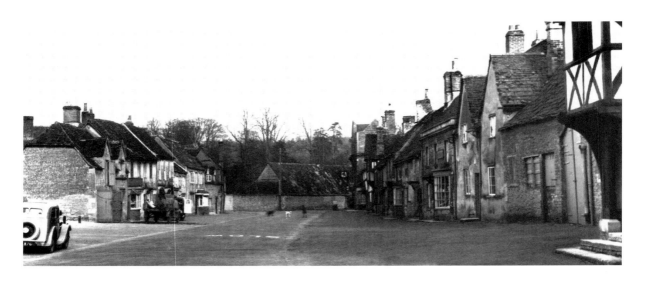

LACOCK, THE HIGH STREET c1955 L1002

Miss Matilda Talbot donated Lacock Abbey, together with most of the village, Manor Farm and Bewley Common, to the National Trust between 1944 and 1946. The lack of TV aerials, white lines, overhead cables and red pillar boxes have made it an ideal location for filming period dramas. The High Street was transformed by the BBC in October 1994 into Meryton, the fictional village in Jane Austen's *Pride and Prejudice*. The red brick exterior of the Red Lion, far right, built about 1740, became the Assembly Rooms where Elizabeth and Darcy danced.

INTERESTING
BROMHAM FACT

Bromham is twinned with Avoca in County Wicklow, which was the setting for the BBC drama series *Ballykissangel*.

▶ **LACOCK, CORNER HOUSE, CHURCH STREET c1955** L1006

Little has changed of this view of the corner of Church Street and West Street since the houses were built. Next to Corner House is one of the oldest houses in Lacock (centre left): the 14th-century Cruck House combines timber, stone and brick, and its cruck construction is exposed on the other side, a rare example in southern England.

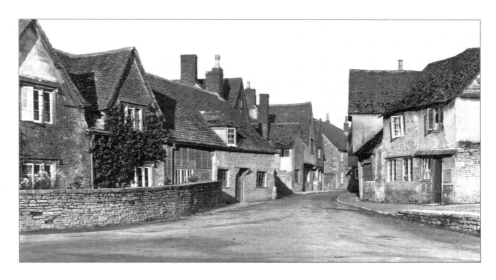

◀ **BROMHAM, ST NICHOLAS CHURCH 1899** 44854

This church has the most impressive chantry in a Wiltshire village church, according to Derek Parker and John Chandler in *Wiltshire Churches, an Illustrated History*. Built about 1492 by Richard Beauchamp, the Baynton Chapel has fine external features, 'battlements with quatrefoils and pinnacles with their decorations' (Pevsner). The 1510 octagonal stone spire was under repair at the time of this picture, as we can see from the wooden scaffolding.

**BROMHAM,
THE CHURCH, TOM
MOORE'S GRAVE
1899** 44855

An 18ft-high Celtic cross
made from Irish granite
now marks the Irish
poet's grave. The railings
were removed and the
new memorial erected
and dedicated on 24
November1906. Lines
from one of Moore's
poems, beginning 'Dear
Harp of my country in
darkness I found thee',
appear below the cross.

BROMHAM, TOM MOORE'S HOUSE 1899 44856

Tom Moore lived at Sloperton Cottage, Westbrook for nearly 34 years whilst under the patronage of the Earl of Shelburne.
Pevsner describes the early 19th-century house thus: 'With pretty Gothic trim, including a porch and a bay window'.

INDEX

BIBLIOGRAPHY

Architects and Building Craftsmen. Wiltshire Buildings Record 1996

N Beale: Is That the Doctor? A History of the Calne GPs. Norman Beale 1998

N and E Beale: Who was Ingen Housz, Anyway? Calne Town Council 1999

S Boddington: A Source of Pride: A Brief History of Calne Library. Wiltshire County Council Library & Museum Service 1993

A G Bradley: Round About Wiltshire. Methuen 1928

J Britton: The Beauties of Wiltshire Vol II 1801

J Bromham: C&T Harris (Calne) Ltd, A Brief History. 1985

J Bromham: Memoirs of a Small Town Man. 1989

JA Chamberlain: Maud Heath's Causeway. Chippenham Borough Council & Calne & Chippenham Rural District Council 1974

J Cornforth: Bowood, Wiltshire, Revisited. Country Life 1972

G Daniels: Memories of Derry Hill Village. 1990

The Department of National Heritage, Revised List of Buildings of Special Architectural or Historic Interest, District of North Wiltshire, Calne Area 1995

RJ Downham, FC Eley, PQ Treloar: Calne in Camera. Calne Borough Council 1974

Kelly's Directory 1939

A E W Marsh: A History of the Borough and Town of Calne. Robert S Heath, Calne 1903

A Mee: The King's England: Wiltshire. 1965

C G Maggs: The Calne Branch. Wild Swan 1990

C Malone: The Prehistoric Monuments of Avebury. English Heritage 2000

L J Murray: A Zest for Life, the Story of Alexander Keiller. Morven Books 1991

R Onslow: Beckhampton House Past and Present. Wilton 1965

N Pevsner, revised B Cherry: Wiltshire: The Buildings of England. Yale University Press 2002

M Pitts: Footprints Through Avebury. Digging Deeper 1996

K Rogers : Warp and Weft. Barracuda Books 1986

K Stedman: A History of St Mary's, Calne, 1873-1986. B A Hathaway

P Treloar: Around Calne in Old Photographs. Alan Sutton 1990

P Treloar: Calne in Focus. Calne Town Council 1984

P Treloar: Calne in Pictures. Calne Town Council 1982

P Treloar: Calne Revisited. Calne Town Council 1999

P Treloar: Greetings from Calne. Calne Town Council 1988

The Victoria History of the Counties of England: Wiltshire Vol XVII Boydell & Brewer 2002

NAMES OF SUBSCRIBERS

The following people have kindly supported this book by subscribing to copies before publication

The Allison Family, Calne
The Andrews Family, Calne
Marjorie Angell
The Austin Family
Sue Barlow
Wendy Barnes (nee Munns), Calne
The Barnett Family, Calne
The Bartram Family, Calne
Norman & Elaine Beale
The Bennett Family
Steven Bewley
Tim Buckeridge
The Bullock Family, Calne
Mr A. H. F. & Mrs J. Burchell
The Cave Family, Calne
M. J. Cave, Calne
Mr A. E. & Mrs K. J. Chapman, Calne, Wilts
Mr R. H. & Mrs J. M. Chivers
Mr Anthony Clarke, Calne, Wiltshire
Katy Cleland
Mr M. A. & Mrs D. J. Cole, Calne
Elizabeth F. Cook, Calne
Harriet Crampton
Sean & Patsy Crampton
Patrick Joseph Croxford
Mr N. J. & Mrs T. A. Dale
Roy Diccox
Colin Dodd
In Memory of
 Raymond James Downham MBE
Mr R. E. & Mrs P. A. Drew
Mr B. W. Flay and Mrs M. J. Flay
Mr M. J. & L. J. Flay, Calne
M. M. Fraser-Roberts
The Glander Family, Calne
P. C. & W. J. Gleed and B. V. & C. V. Gleed

Candida Grant
The Haines Family, Melbourne, Australia
June Haines, Calne
Vincent & Heather Haines
Gillian Hale
Patricia Hancock
Dale & Sarah Harding,
 Hugh & Owen Harding
In Memory of Ivy M. Harrison, Calne
W. K. Harrison, Calne
June Christine Henly, Calne
The Hughes Family, Heppington
Andrew Hunt & May Hunt
Mr M. D. Jones
Mr R. W. Jones
To the Memory of Julian 1971-2001 (Calne)
Richard K. S. Kidd
Peter George King
Alfred & Dina La Vardera
D. A. Lane - Love from the Family
Francois & Bernadette Launay
Mr Gary Legg
Mr & Mrs K. G. Lewis
Eva Linnegar Ex. B.G.S. Staff.
Diane Lomas & Andrew Driver
Don & Jean Lovelock
The Mackinnon Family, Calne
Mr S. A. & Mrs J. C. Masson, Calne
David Herbert Matthews, Spirthill
Doris & Ian McDonald, Bremhill
The McEvoy Family, Calne
The Merritt Family, Calne
Mr E. G. & Mrs J. E. Merritt, Calne
Charles Mollart, Calne
The Moore Family, Calne
David & Margaret Morgan

The Nicholls Family, Calne
Mr D. & Mrs R. E. Parsons, Calne
D. M. Pearce
Mr J. B. & Mrs S. J. Pieroux
A. E. & C. A. Rengert, Calne
The Richards Family, Calne
Elspet Louise Rivett
Mr G. J. & Mrs R. J. Robinson, Calne
Mr A. Rumming, Compton Bassett
The D. R. & J. M. Shepherd Family, Calne
Mr & Mrs D. J. Sims
Mr E. J. Skull
The Slade Family, Calne
G. K. Smith, Calne
Edward & Patricia Spooner
Mr C. Stewart, Calne
In Memory of Christopher Summers, Calne
Malcolm S. Sumpter

In Memory of Walter Sutton, Calne
Geoffrey H. Thorne
Christopher Tompkins
Betty & Michael Townsend and Family
Peter Treloar
Manfred & Dorothea Urban
Mr A. J. Walker & Mrs B. M. Walker, Calne
Margaret & John Walton, Calne
Mr P. J. & Mrs J. Watts, Calne
Nigel Webster, Calne
S. M. Wells
E. G., L. S & Rebecca Weston
Derek Witchell, Sandra Witchell, Calne
In Memory of Frank & Florence Witchell
Mr L. A. & Mrs H. A. Withers, Calne
A. M. Wood, Calne
Mr G. Wood
Fred & Margaret Zebedee, Calne

FRITH PRODUCTS & SERVICES

Francis Frith would doubtless be pleased to know that the pioneering publishing venture he started in 1860 still continues today. Over a hundred and forty years later, The Francis Frith Collection continues in the same innovative tradition and is now one of the foremost publishers of vintage photographs in the world. Some of the current activities include:

Interior Decoration

Today Frith's photographs can be seen framed and as giant wall murals in thousands of pubs, restaurants, hotels, banks, retail stores and other public buildings throughout the country. In every case they enhance the unique local atmosphere of the places they depict and provide reminders of gentler days in an increasingly busy and frenetic world.

Product Promotions

Frith products are used by many major companies to promote the sales of their own products or to reinforce their own history and heritage. Frith promotions have been used by Hovis bread, Courage beers, Scots Porage Oats, Colman's mustard, Cadbury's foods, Mellow Birds coffee, Dunhill pipe tobacco, Guinness, and Bulmer's Cider.

Genealogy and Family History

As the interest in family history and roots grows world-wide, more and more people are turning to Frith's photographs of Great Britain for images of the towns, villages and streets where their ancestors lived; and, of course, photographs of the churches and chapels where their ancestors were christened, married and buried are an essential part of every genealogy tree and family album.

Frith Products

All Frith photographs are available Framed or just as Mounted Prints and Posters (size 23 x 16 inches). These may be ordered from the address below. From time to time other products - Address Books, Calendars, Table Mats, etc - are available.

The Internet

Already fifty thousand Frith photographs can be viewed and purchased on the internet through the Frith websites and a myriad of partner sites.

For more detailed information on Frith companies and products, look at these sites:

www.francisfrith.co.uk
www.francisfrith.com
(for North American visitors)

See the complete list of Frith Books at:

www.francisfrith.co.uk

This web site is regularly updated with the latest list of publications from the Frith Book Company. If you wish to buy books relating to another part of the country that your local bookshop does not stock, you may purchase on-line.

For further information, trade, or author enquiries please contact us at the address below:
The Francis Frith Collection, Frith's Barn, Teffont, Salisbury, Wiltshire, England SP3 5QP.
Tel: +44 (0)1722 716 376 Fax: +44 (0)1722 716 881 Email: sales@francisfrith.co.uk

See Frith books on the internet at www.francisfrith.co.uk

FREE MOUNTED PRINT

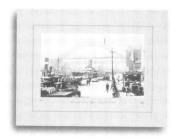

Mounted Print
Overall size 14 x 11 inches

Fill in and cut out this voucher and return
it with your remittance for £2.25 (to cover postage and handling). Offer valid for delivery to UK addresses only.

Choose any photograph included in this book.
Your SEPIA print will be A4 in size. It will be mounted in a cream mount with a burgundy rule line (overall size 14 x 11 inches).

**Order additional Mounted Prints
at HALF PRICE (only £7.49 each*)**
If you would like to order more Frith prints from this book, possibly as gifts for friends and family, you can buy them at half price (with no additional postage and handling costs).

Have your Mounted Prints framed
For an extra £14.95 per print* you can have your mounted print(s) framed in an elegant polished wood and gilt moulding, overall size 16 x 13 inches (no additional postage and handling required).

*** IMPORTANT!**

These special prices are only available if you order at the same time as you order your free mounted print. You must use the ORIGINAL VOUCHER on this page (no copies permitted). We can only despatch to one address.

Send completed Voucher form to:
The Francis Frith Collection, Frith's Barn, Teffont, Salisbury, Wiltshire SP3 5QP

CHOOSE ANY IMAGE FROM THIS BOOK

Voucher for **FREE** and Reduced Price Frith Prints

Please do not photocopy this voucher. Only the original is valid, so please fill it in, cut it out and return it to us with your order.

Picture ref no	Page no	Qty	Mounted @ £7.49	Framed + £14.95	Total Cost
		1	Free of charge*	£	£
			£7.49	£	£
			£7.49	£	£
			£7.49	£	£
			£7.49	£	£
			£7.49	£	£

Please allow 28 days for delivery

* Post & handling (UK)	£2.25
Total Order Cost	£

Title of this book .

I enclose a cheque/postal order for £
made payable to 'The Francis Frith Collection'

OR please debit my Mastercard / Visa / Switch / Amex card
(credit cards please on all overseas orders), details below

Card Number

Issue No (Switch only) Valid from (Amex/Switch)

Expires Signature

Name Mr/Mrs/Ms ...

Address ...

...

...

..................................... Postcode

Daytime Tel No ...

Email ..

Valid to 31/12/05

Would you like to find out more about Francis Frith?

We have recently recruited some entertaining speakers who are happy to visit local groups, clubs and societies to give an illustrated talk documenting Frith's travels and photographs. If you are a member of such a group and are interested in hosting a presentation, we would love to hear from you.

Our speakers bring with them a small selection of our local town and county books, together with sample prints. They are happy to take orders. A small proportion of the order value is donated to the group who have hosted the presentation. The talks are therefore an excellent way of fundraising for small groups and societies.

Can you help us with information about any of the Frith photographs in this book?

We are gradually compiling an historical record for each of the photographs in the Frith archive. It is always fascinating to find out the names of the people shown in the pictures, as well as insights into the shops, buildings and other features depicted.

If you recognize anyone in the photographs in this book, or if you have information not already included in the author's caption, do let us know. We would love to hear from you, and will try to publish it in future books or articles.

Our production team

Frith books are produced by a small dedicated team at offices in the converted Grade II listed 18th-century barn at Teffont near Salisbury, illustrated above. Most have worked with the Frith Collection for many years. All have in common one quality: they have a passion for the Frith Collection. The team is constantly expanding, but currently includes:

Paul Baron, Jason Buck, John Buck, Ruth Butler, Heather Crisp, David Davies, Isobel Hall, Julian Hight, Peter Horne, James Kinnear, Karen Kinnear, Tina Leary, Stuart Login, David Marsh, Sue Molloy, Glenda Morgan, Wayne Morgan, Kate Rotondetto, Dean Scource, Eliza Sackett, Terence Sackett, Sandra Sampson, Adrian Sanders, Sandra Sanger, Julia Skinner, Claire Tarrier, Lewis Taylor, Shelley Tolcher, Lorraine Tuck and Jeremy Walker.

Free Print – see overleaf